Santa Clara County

Rick Sprain

Introduction by Judge Paul Bernal

ARCADIA
PUBLISHING

Published by Arcadia Publishing
Charleston, South Carolina

Printed in the United States of America

Library of Congress Control Number: 2017952456

For all general information contact Arcadia Publishing at:
Telephone 843-853-2070
Fax 843-853-0044
E-mail sales@arcadiapublishing.com
For customer service and orders:
Toll-Free 1-888-313-2665

Visit us on the Internet at www.arcadiapublishing.com

This book is dedicated to all of the men and women of law enforcement who proudly safeguard the citizens of Santa Clara County.

CONTENTS

ACKNOWLEDGMENTS

Having grown up and worked in Santa Clara County for most of most of my life, this book was more of a labor of love than anything else. History and Santa Clara County to me are synonymous, both having been intertwined in my life since I was a kid and through my many years with the sheriff's office. My time with the Santa Clara County Historical Commission almost 20 years ago allowed me to meet some of the most renowned historians in the county, many of whom I still count as friends and who helped with and contributed to this book.

One of the first people I met on the board is San Jose historian and Santa Clara County superior court judge Paul Bernal. Paul can trace his family back hundreds of years to early Santa Clara County and was kind enough to write the introduction. Longtime friend and Los Gatos historian Bill Wulf opened up his private collection of postcards for me. There isn't a better collection of early and rare postcards of Santa Clara County in the state. The late Edith Smith, who headed up the Sourisseau Academy at San José State University many years ago, was gracious enough to leave her vast postcard collection to the academy, and quite a few appear in this book. Portions of her collection were contributed by Jack Douglas, Leonard McKay, and Steve Carlson. Charlene Duval and Leilani Marchall from Sourisseau Academy spent hours combing through the collections, finding some wonderful postcards for the book. Kitty Monahan and the Santa Clara County Parks Department, along with the New Almaden Museum, allowed me to scan postcards of the Almaden area. I would also like to thank Erin Herzog from the California Room at the San José Public Library, Mary Boyle from the City of Santa Clara Public Library, and Lisa Christiansen of the Stocklmeir Library at the California History Center at De Anza College and the California State Library for assisting me in this endeavor.

All images in this book are from my personal collection unless otherwise noted.

INTRODUCTION

Ah, wonderful postcards! We all love them.

Rick Sprain artfully tells the story of Santa Clara County through a collection of card-sized keepsakes. The highs and the lows—from major civic accomplishments to disgraceful public hangings. He captures what made the valley significant.

Because postcards are snapshots of time, they bear witness to both progress and decline. Sleepy towns became huge metropolitan areas. Even with this seismic shift in population, postcards also illustrate that some things have not changed at all.

As we take our pictorial journey into the past, we can see the vastness of the agricultural boom that catapulted a collection of humble cities into a hub of commerce. We can smell the delightful fruit blossoms that carpeted the valley. These orchards produced the abundance of crops for which Santa Clara Valley earned it fame, as well as the myriad of transportation routes to get those crops to market. We shipped it all—including apricots, peaches, plums, and cherries. Santa Clara County was home to major wineries and the massive prune industry. And pictures were taken to send around the world to tell friends what was going on in this valley.

This imagery takes us from one end of the county to the other: Palo Alto to Gilroy; Alviso to Los Gatos. In between the major cities, we get to wistfully gaze upon forgotten towns that are memorialized in postcards: Patchen, Holy City, Alma, and Agnew. Once vibrant communities are now submerged beneath dammed lakes. Besides these man-made erasures, we get to witness the destructive power of Mother Nature upon our county via earthquakes and floods. All put to postcards.

Rick Sprain lets us sit in the passenger seat as he drives us through adventurous mountain roads up to picturesque valley views. On this auto-tour, we not only get to peek into little resorts, but also gaze at big attractions. Roadside stops such as Casa de Fruita are found alongside spectacular features such as the Winchester Mansion. We see that early amusement parks such as Frontier Village were eclipsed by vast amusement parks like Great America.

The history is there for us to see. But why do postcards exist at all? Holding something in one's hand makes the holder part of the experience depicted in the postcard. In a way, the holder possesses the event, and has the ability to easily share the event with others by merely affixing postage. As we all know, a picture is worth a thousand words. That is why postcards are an exceptional and affordable form of communication.

As soon as there were printing presses in Santa Clara County, postcards were being created in this valley. Postcards are fun keepsakes; they evoke memories of a trip; they denote "I was there," and "Wish you were here." In a world of instantaneous electronic communication, postcards still

survive. Surprisingly, about 100 million are sent each year in the United States. It is a function of both convenience and nostalgia. Who doesn't relish receiving a postcard? They are far more personal and interesting than common mail. They make life enjoyable.

When mailed back to loved ones, a postcard not only boasts "I was here," but also says "I am thinking of you." The mailing shares the traveler's experience with others. It's about connection. By the act of sending a postcard, the sender connects with the happening; the recipient is likewise connected via the cardstock photograph to the happening; and the recipient is connected to the sender. It's what humans do—they desire connection. It's sharing a story, as people have done since the beginning of society, only now accomplished across thousands of miles by way of paper, ink, and the mail service.

As a means of expression, postcards reflect the character of the sender (and sometimes the character of the recipient): humor, beauty, bigotry, poetry, and cheekiness. Some are whimsical, some stoic, some colorful, and others gruesome.

Some people use postcards as a chronicle of their adventures: they replace a camera and film with thin cards tucked into a suitcase, so that the explorer upon returning home can show relatives the postcards that capture the magnificent wonders that were seen.

For postcard collectors, some images are cheap, crude compositions, while others are mini masterpieces worthy of framing. Regardless of their quality, they are all meant to record "what I saw."

From a historical perspective, postcards are literally and figuratively snapshots of time—they illustrate a particular community's values, pride, accomplishments, tragedies, honors, and events. During the heyday of postcards, there was no topic that was missed by the lens of the camera: civic buildings, parades, wartime preparations, train wrecks, campouts, visits by dignitaries, agricultural industry, and everyday life. This recordation is significant today because it left a trail of what was important to that now-gone society.

Although postcards are quickly being replaced by phone snapshots sent instantaneously, we love the stories revealed by a book of postcard images as much as we are still thrilled to get a singular postcard in the mail. Have fun!

—Hon. Judge Paul Bernal
Official Historian of the City of San Jose

One

Towns and Communities of Santa Clara County

Past and Present

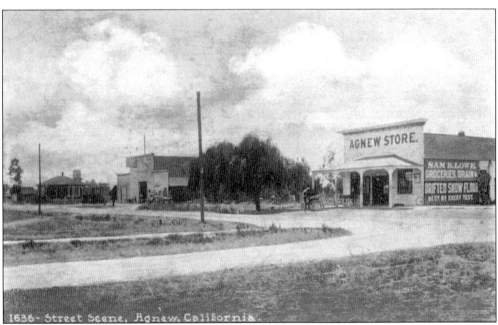

AGNEW, STREET SCENE, POSTMARKED OCTOBER 23, 1912 (DIVIDED BACK POSTCARD).
The small town was named after Abram Agnew, an early pioneer in Santa Clara County. In the 1870s, Agnew donated four acres of land for a Southern Pacific Coast Railroad station and began laying out the new town. In 1889, the State of California established a hospital in Agnew to treat the mentally ill. The City of Santa Clara annexed Agnew in 1980, and the state closed down the hospital in the 1970s. In 1996, the State of California sold the land to Sun Microsystems, which located its corporate headquarters there while preserving many of the original buildings. Although no longer used, the old train depot is still standing. (Published by Edward H. Mitchell.)

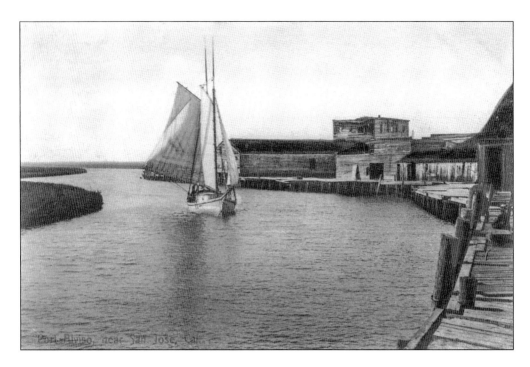

ABOVE: PORT ALVISO, POSTMARKED JUNE 29, 1910 (HAND-COLORED POSTCARD); BELOW: THE NEW PORT, C. 1910 (DIVIDED BACK POSTCARD). The city of Alviso was incorporated in 1852 and soon became the shipping port for San Jose and the rest of Santa Clara County. Steamboats regularly traveled between San Francisco and Alviso, but boat traffic began declining in the 1860s with the railroad coming to the county. The town of Alviso was absorbed into the city of San Jose on March 12, 1968. (Above, published by M. Rieder, Publ.)

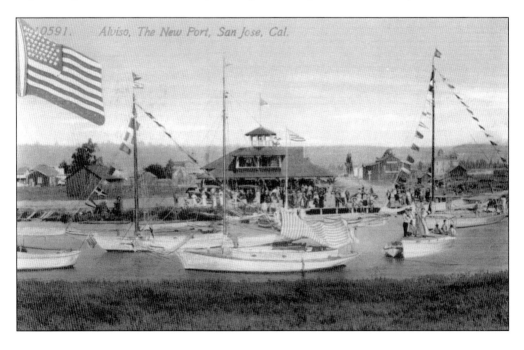

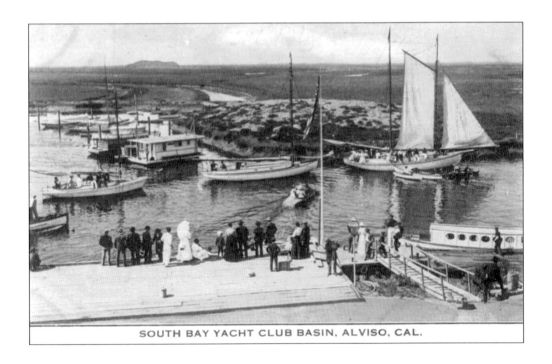

SOUTH BAY YACHT CLUB BASIN, ALVISO, CAL.

ABOVE: ALVISO, SOUTH BAY YACHT CLUB, C. 1915 (REAL-PHOTO POSTCARD); BELOW: C. 1905 (REAL-PHOTO POSTCARD). Founded in 1888, the South Bay Yacht Club is one of the oldest in the Bay Area. It was started by 35 wealthy local businessmen who originally called it the South Bay Yachting Association. The clubhouse was built in 1902 and was moved to its current site in the mid-1980s due to realignment of the levees. (Above, published by E. Hess; below, courtesy California Room, San José Public Library.)

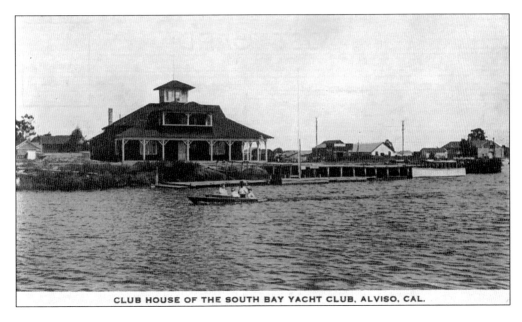

CLUB HOUSE OF THE SOUTH BAY YACHT CLUB, ALVISO, CAL.

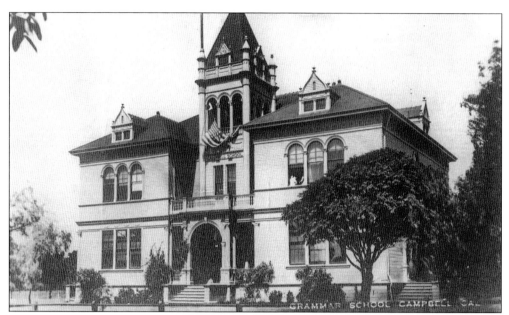

CAMPBELL, GRAMMAR SCHOOL, 1900–1910 (REAL-PHOTO POSTCARD). Constructed in 1896 on the northeast corner of Winchester and Rincon Avenues, the first grammar school (seen here) was replaced in 1916. This school only lasted a few years and was replaced in 1922. The third grammar school closed in 1964 and was added to the National Register of Historic Places in 1979. (Courtesy Sourisseau Academy for State and Local History, San José State University.)

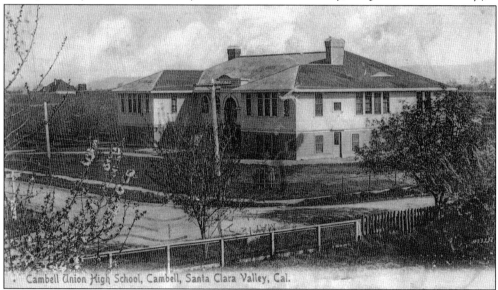

CAMPBELL, UNION HIGH SCHOOL, C. 1908 (REAL-PHOTO POSTCARD). The original Campbell High School opened on September 14, 1900, and was located on the second floor of the Campbell Grammar School. In 1904, principal Fred Smith moved the high school to a new building on the southeast corner of Winchester and Campbell Avenues. Then, in 1936, the high school moved to the northwest corner of the same intersection until 1980, when the district closed the school. (Published by Alice Hare, courtesy Sourisseau Academy for State and Local History, San José State University.)

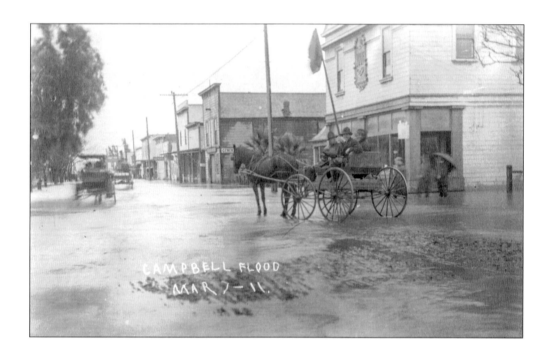

Campbell, Flood, c. 1911 (Real-Photo Postcards). Over a two-day period in March 1911, Campbell residents saw over 13 inches of rain pour down on their town. The torrential rainstorm caused the Los Gatos Creek to flood its banks and flow into the surrounding countryside, inundating downtown businesses. (Both, courtesy Sourisseau Academy for State and Local History, San José State University.)

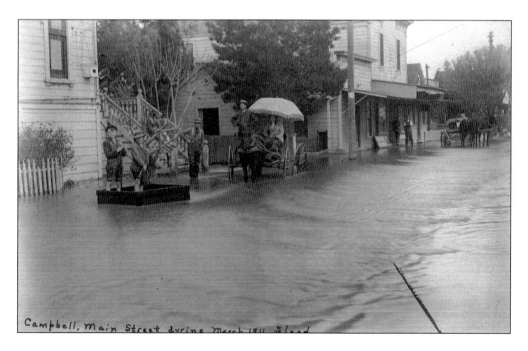

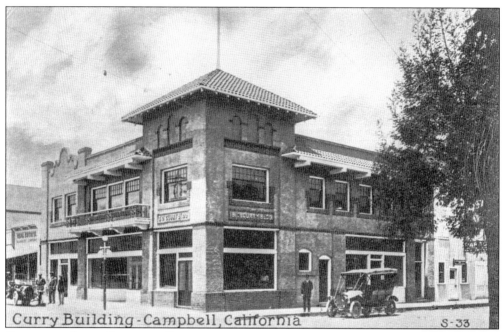

CAMPBELL, CURRY BUILDING, POSTMARKED SEPTEMBER 6, 1912 (DIVIDED BACK POSTCARD).
Built around the time this postcard was mailed, the B.O. Curry Building is located at 401–415 East Campbell Avenue. Curry used the building, constructed in the Mission Revival style, for his real estate and insurance businesses. For six years, from 1914 to 1920, the Curry Building was also the Campbell Post Office. (Published by Souvenir Publishing.)

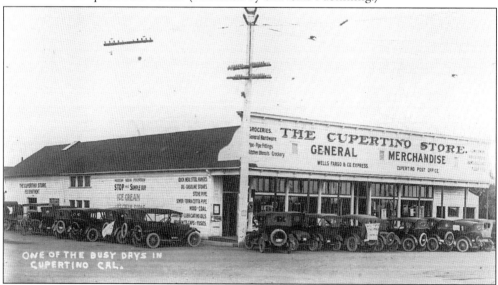

CUPERTINO, GENERAL STORE, C. 1915 (REAL-PHOTO POSTCARD). First known as West Side, the small farming community settled around the crossroads now known as De Anza and Steven Creek Boulevards. In 1898, the town changed its name to Cupertino after a local creek with the same name. Soon after, the Home Union Store also changed its name to the Cupertino Store and relocated to the northeast corner of the crossroads. (Courtesy California History Center, De Anza College.)

CUPERTINO, VIEW FROM HOO HOO HILL, C. 1920 (REAL-PHOTO POSTCARD). The Hoo Hoo is a fraternity made up of people in the lumber industry who constructed a lodge for the 1915 Panama-Pacific International Exposition in San Francisco. When the fair ended, Cupertino developer George Hensley purchased the lodge and had it rebuilt on the high point of Inspiration Heights in Cupertino. The hill, located west of the Blackberry Farms Golf Course, soon became known as Hoo Hoo Hill. (Courtesy California History Center, De Anza College.)

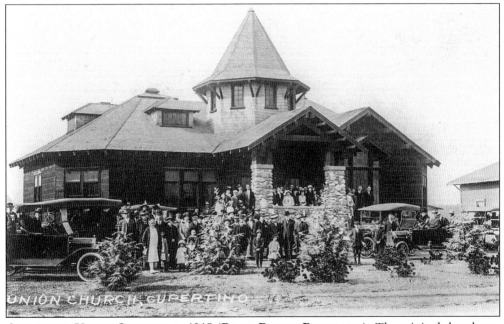

CUPERTINO UNION CHURCH, C. 1915 (REAL-PHOTO POSTCARD). The original church was constructed in 1884 on the corner of Stevens Creek and De Anza Boulevards. In the late 1950s, the church relocated to 20900 Stevens Creek Boulevard, just north of its original site. (Courtesy California History Center, De Anza College.)

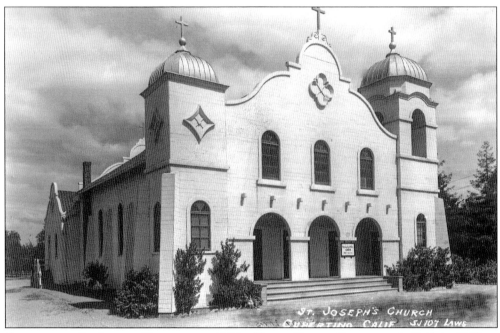

CUPERTINO, ST. JOSEPH CHURCH, C. 1940S (REAL-PHOTO POSTCARD). Built in 1907 on De Anza Boulevard just north of Stevens Creek Road, the St. Joseph Church served Cupertino for 46 years. In 1953, the old church was demolished and a new parish was constructed on the same site. (Published by Casper Laws, courtesy Sourisseau Academy for State and Local History, San José State University.)

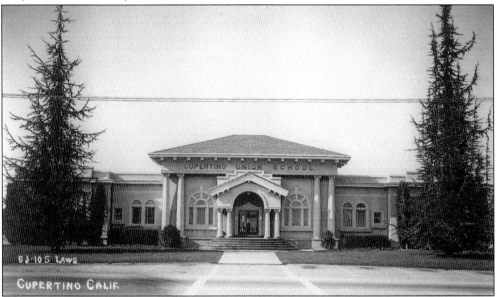

CUPERTINO, UNION SCHOOL, C. 1940–1950 (REAL-PHOTO POSTCARD). Cupertino Union School opened on the corner of Stevens Creek and Vista Drive in 1921. It was the first school constructed under the new Cupertino Union School District, which formed in 1915. (Published by Casper Laws, courtesy Sourisseau Academy for State and Local History, San José State University.)

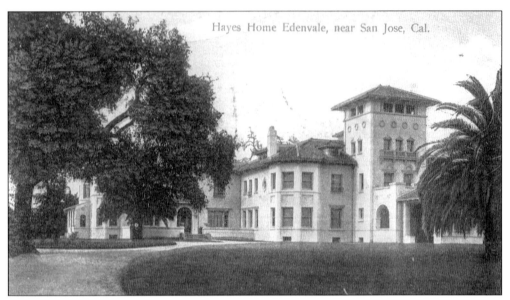

Hayes Home Edenvale, near San Jose, Cal.

EDENVALE, HAYES HOME, C. 1910S (DIVIDED BACK POSTCARD). Constructed in 1903, the 41,000- square-foot mansion was commissioned by Mary Chynoweth to replace the family home that burned down in 1899. The City of San Jose purchased the property in 1984 for $2.5 million to restore the mansion into a hotel and conference center. The venture never earned money for the city, which sought to sell the property for $47 million in 2016. (Published by M. Rieder, Publ.)

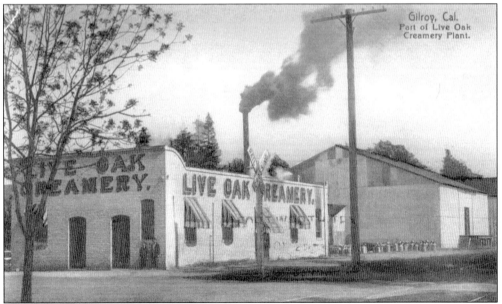

Gilroy, Cal.
Part of Live Oak
Creamery Plant.

GILROY, LIVE OAK CREAMERY, POSTMARKED NOVEMBER 22, 1911 (HAND-PAINTED POSTCARD). Opening in 1908, the Live Oak Creamery was the first butter factory and first insulated building in Gilroy. During the early 1920s, the creamery also included cheese processing. Located at 88 Martin Street near Railroad Street, the building still stands as a testament to Gilroy's historic past. Due to tighter state regulations, the business closed its doors around 1940. (Published by Pacific Novelty Co.)

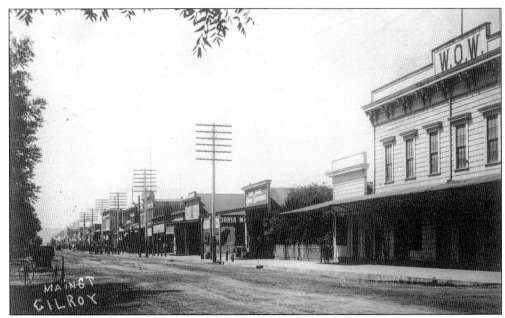

ABOVE: GILROY, MAIN STREET, DATED 1911 (REAL-PHOTO POSTCARD); BELOW: NORTH ON MONTEREY STREET, C. 1910 (REAL-PHOTO POSTCARD). An early pioneer to California, John Gilroy jumped ship in Monterey in 1814 and, in 1821, married the daughter of Rancho San Ysidro patriarch Ygnacio Ortega. Upon Ortega's death in 1833, the property was divided amongst his wife and three children, who included Gilroy's wife, Maria Clara. Many years later, after California became a state and under US property laws, the rancho was deeded to Gilroy in 1867. Growing around Gilroy's Rancho, the settlement became known as "Old Gilroy," but by 1870, when the town incorporated, the town center moved closer to Monterey Road. (Both, courtesy the California History Room, California State Library, Sacramento, California.)

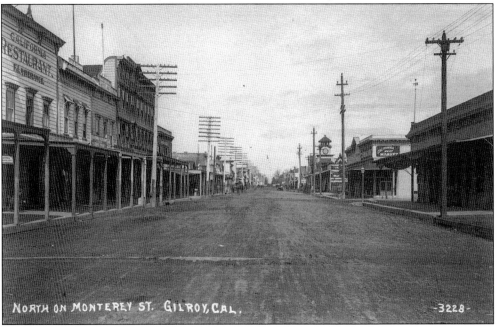

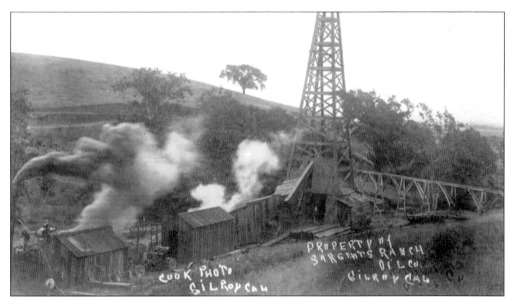

GILROY, SARGENT'S RANCH OIL, C. 1910 (REAL-PHOTO POSTCARD). Oil was originally discovered near the Santa Clara and San Benito County line, well back into the Mexican era of California. The first test wells were sunk in the 1860s, and by the 1870s, a number of wells were producing oil. The last well was shut down in 1948. An article appearing in the *San Jose Evening News* on June 20, 1904, relates the "well was producing one railroad car a day of oil, and as soon as a new well was in production, the shipments would increase to three cars a day."

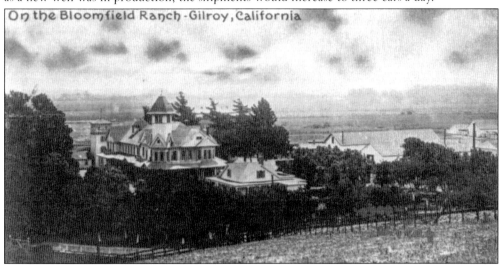

GILROY, BLOOMFIELD RANCH, POSTMARKED OCTOBER 20, 1915 (HAND-COLORED POSTCARD). Heinrich Kreiser came from Germany to New York in 1846, assuming the name of his friend Henry Miller. Coming to California to join the gold rush, Miller ended up opening a butcher shop in San Francisco. By the 1850s, he went into a partnership with Charles Lux, purchasing land and cattle throughout the south county area as well as other areas of California. In the late 1850s, Miller purchased the Los Animas Rancho in the Gilroy area and named it Bloomfield Ranch. In addition to the general store, blacksmith shop, and granaries, Miller even had his own railroad station on the ranch. In 1888, he had a 42-room mansion constructed on the property; it burned down in 1923. (Published by Pacific Novelty Co.)

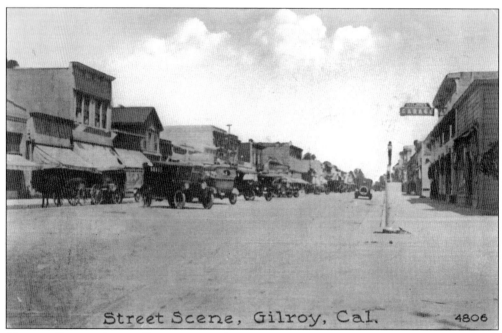

GILROY, STREET SCENE, POSTMARKED SEPTEMBER 19, 1923 (DIVIDED BACK POSTCARD).
This picture was probably taken on Monterey Road near Sixth Street from a location in front of what is now the Old City Hall. Although a few of these buildings are still standing, their appearances have changed so dramatically that many are barely recognizable. (Published by Pacific Novelty Co.)

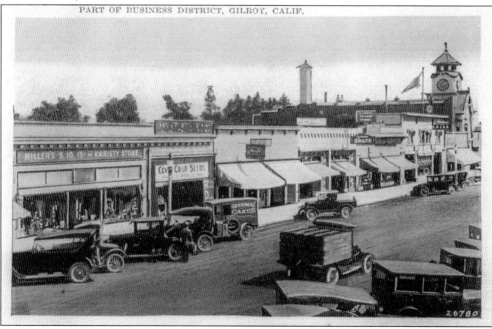

GILROY, PART OF BUSINESS DISTRICT, C. 1930 (DIVIDED BACK POSTCARD). Constructed in 1905, the clock tower at the far right still sits atop the Old City Hall building at the corner of Monterey Road and Sixth Street. (Published by M. Kashower Co.)

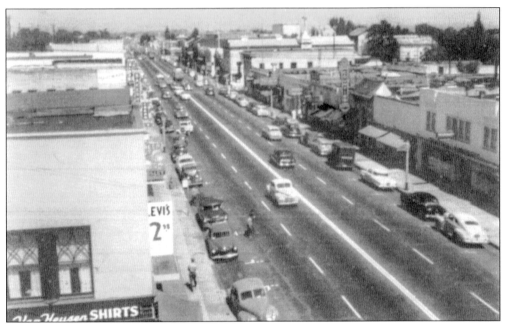

GILROY, DOWNTOWN, C. 1940s (REAL-PHOTO POSTCARD). With a view looking north on Monterey Street from Sixth Street, this photograph was probably taken from the roof of the old Milias Hotel sometime in the 1940s. (Published by Frye & Smith Ltd.)

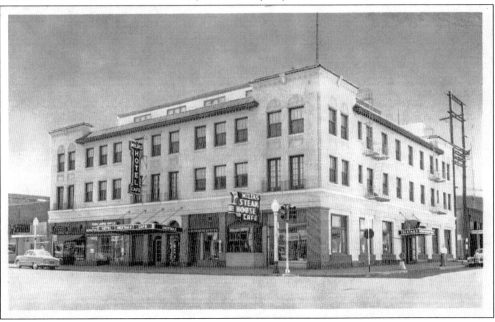

GILROY, MILIAS HOTEL, C. 1940s (ADVERTISING POSTCARD). Opening in 1922, the Milias Hotel, along with the Milias Restaurant and Steakhouse, was one of the premier hotels of its time, with Hollywood stars such as Clark Gable, John Wayne, Bing Crosby, Bob Hope, and Will Rogers having visited. The hotel closed years ago and has since been redesigned and opened as the Milias Apartments. The restaurant also went through its own refurbishing and reopened around 2010 as the Milias Restaurant. (Published by Schwabacher/Frey Co.)

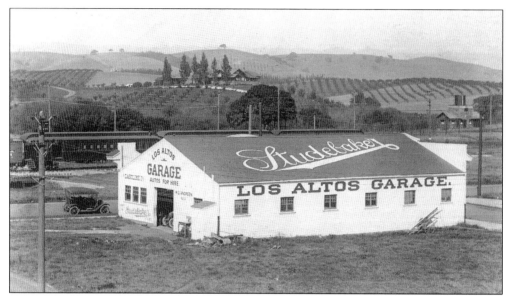

Los Altos, Garage, 1910–1915 (Real-Photo Postcard). According to a Studebaker advertisement in the *San Jose Mercury* from October 15, 1916, a brand-new four-cylinder touring car could be purchased at the Los Altos Garage for $875. A six-cylinder version of the same automobile was $1,085. Now, if one had money and wanted the seven-passenger limousine, the retail price was $2,600. (Courtesy Sourisseau Academy for State and Local History, San José State University.)

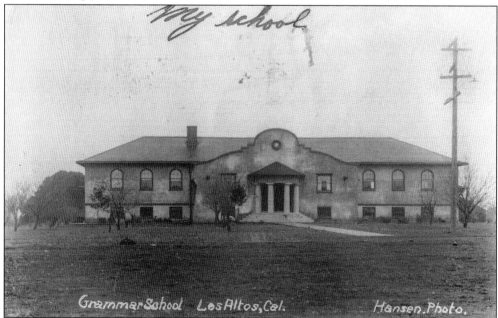

Los Altos, Grammar School, 1911–1916 (Real-Photo Postcard). Prior to construction of a new school, grammar school students would use the second floor of the Shoup Building on Main Street. In 1911, the Los Altos Grammar School was constructed on San Antonio Road south of downtown. (Photograph by Hansen, courtesy Sourisseau Academy for State and Local History, San José State University.)

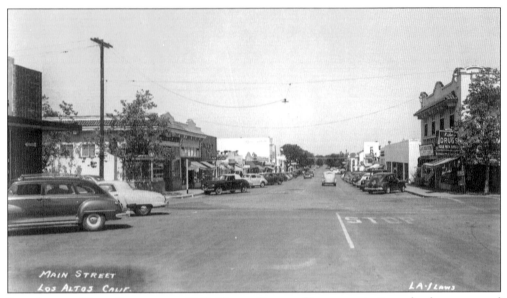

LOS ALTOS, MAIN STREET, C. 1949 (REAL-PHOTO POSTCARD). From land once owned by Sarah Winchester, the widow of William Winchester, the inventor of the Winchester rifle, a group of investors purchased 140 acres in 1906 with the expressed interest of creating a new community. To squash any plans from the neighboring cities of Palo Alto and Mountain View to annex Los Altos, the town incorporated on December 1, 1952. (Both, published by Casper Laws, courtesy Sourisseau Academy for State and Local History, San José State University.)

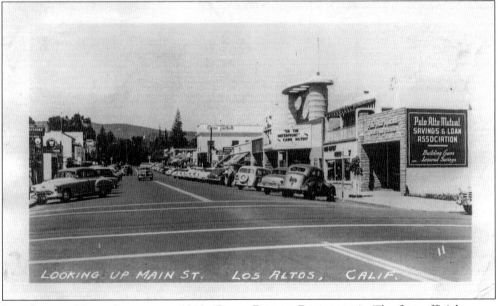

LOS ALTOS, MAIN STREET, C. 1953 (REAL-PHOTO POSTCARD). The first official census after incorporation was in 1960, with the population of Los Altos being 19,696. Ten years later, in 1970, the population grew a little over 5,000, to 24,956. In 1990, the population reached 26,303, and, by 2010, was 28, 976. By 2020, the estimated population of Los Altos will have grown to about 32,000. (Above, courtesy Sourisseau Academy for State and Local History, San José State University; below, photograph by Sandor Balatoni, published by Smith Novelty Co.)

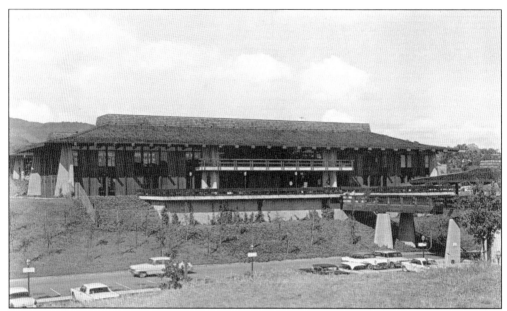

Los Altos Hills, Foothill College, c. 1960s (Real-Photo Postcard). The Foothill–De Anza Community College District was founded in 1957 and opened its first campus, known as Foothill College, at the old Highway School campus on El Camino Real in Mountain View in 1958. The school relocated to its 122-acre campus in Los Altos Hills in 1961. (Photograph by and published by Bob Wyer Photo Cards.)

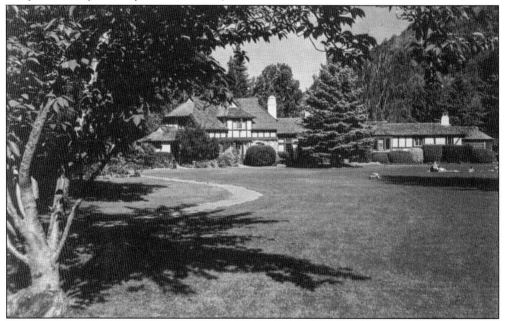

Los Altos Hills, Adobe Creek Lodge, Postmarked June 4, 1956 (Real-Photo Postcard). Built as an English country-style mansion in 1935 by Consolidated Chemicals' vice president Milton Haas, the Adobe Creek Lodge became a destination resort in the 1940s. Bandleaders such as Jimmy Dorsey and Harry James played there regularly. (Published by Mike Roberts Color Prod.)

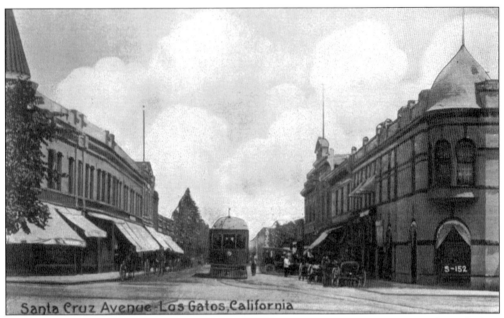

Santa Cruz Avenue–Los Gatos, California

LOS GATOS, SANTA CRUZ AVENUE, C. 1915 (DIVIDED BACK POSTCARD). Los Gatos derives its name from the original 1839 La Rinconada de Los Gatos Mexican land grant—meaning in Spanish "corner of the cats," after the many cougars that once inhabited the area. The community founding dates back to the establishment of the Forbes Flour Mill in 1850. The town itself was established in the 1860s and incorporated in 1887. (Published by Souvenir Publishing Co.)

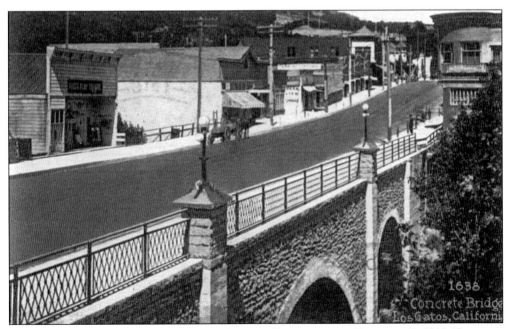

Concrete Bridge Los Gatos, California

LOS GATOS, CONCRETE BRIDGE MAIN STREET, POSTMARKED OCTOBER 7, 1912 (DIVIDED BACK POSTCARD). Completed just prior to the April 18, 1906, earthquake, the Main Street bridge replaced an inadequate trestle-style bridge. The bridge was demolished in 1954 and replaced with the current bridge crossing Highway 17. (Published by Edward H. Mitchell.)

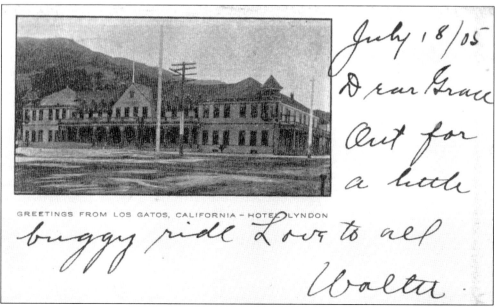

Above: Los Gatos, Hotel Lyndon, Postmarked 1905 (Private Mailing Card); Below: Los Gatos, Santa Cruz Avenue, Postmarked June 9, 1908 (Undivided Back Postcard). The Hotel Lyndon sat on the site of the former Los Gatos Hotel on Santa Cruz Avenue and Main Street. The Hotel Lyndon opened in 1899, one year after the Los Gatos Hotel burned to the ground after a gas lamp exploded. By the 1960s, the Hotel Lyndon had lost its usefulness and was torn down in 1963. An article from the April 9, 1905, *San Jose Mercury News* notes, "The visitor to Los Gatos is agreeably surprised and invariably pleased with the hotel accommodations. For example take the Hotel Lyndon, which is a fair illustration of Los Gatos hostelry. It is a handsome two-story structure, is beautifully located and commands a fair view of the foothills of Los Gatos and the towering mountains in the distance."

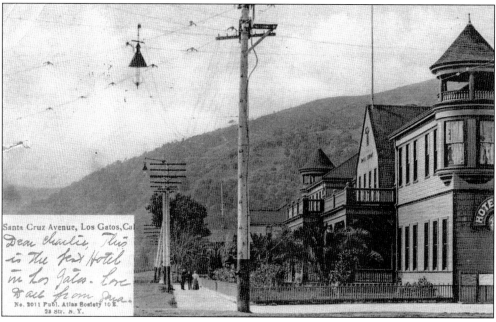

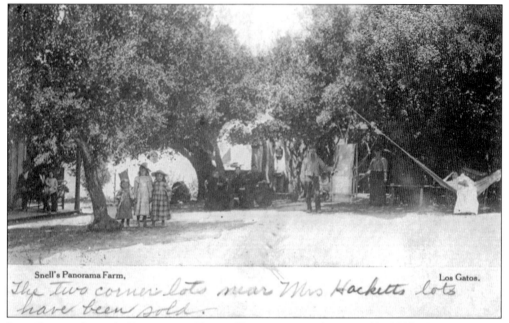

LOS GATOS, SNELL'S PANORAMA FARM, POSTMARKED AUGUST 19, 1909 (REAL-PHOTO POSTCARD). Late in the 1800s, Daniel James Snell and his eldest son, John, began planting their fruit farm on Foster Road above Los Gatos. With sweeping views of Los Gatos and the Santa Clara Valley, the Snell's developed part of the property as a resort, renting cabins from $8 to $10 a week.

LOS GATOS, FLUME, C. 1930S (REAL-PHOTO POSTCARD). Built in 1871 by the San Jose Water Company to bring water to Los Gatos, a wooden flume was constructed from Jones Dam above Alma to Los Gatos. It was rebuilt in 1880, then again in 1935, when it was replaced with a galvanized steel aqueduct. (Courtesy William A. Wulf.)

LOS GATOS, TOWN VIEW, C. 1940S (REAL-PHOTO POSTCARD). In this photograph taken around 1940, the newly constructed Highway 17 is visible leaving Los Gatos toward Santa Cruz. The last Southern Pacific Train left Los Gatos for Santa Cruz in March 1940, which was the same year SR 17 opened. The area in which railroad tracks are visible between Santa Cruz and University Avenues is now a long line of parking lots.

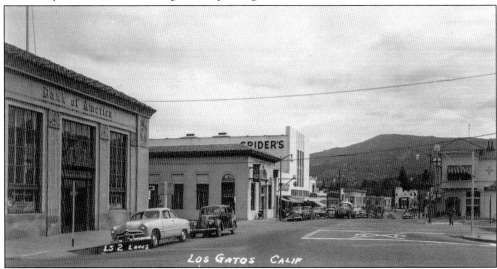

LOS GATOS, DOWNTOWN, C. 1950S (REAL-PHOTO POSTCARD). Originally known as Forbes Mill in the 1850s, the town underwent a name change to Los Gatos, after the Spanish land grant. It has always been one of the smaller communities in Santa Clara County. In 1880, Los Gatos's population was only 555 people, and by 1900, it increased to 1,915. Twenty years later, in 1920, the population had only increased slightly to 2,317. The largest jump occurred between 1940 (with 3,597) and 1970 (with 23,735). The city gained less than 6,000 people between 1970 and 2010, when the population hit 29,413. (Courtesy William A. Wulf.)

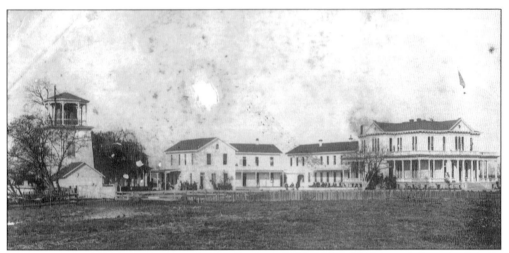

MILPITAS, ALMSHOUSE, 1909 (REAL-PHOTO POSTCARD). The current site of the Elmwood County Jail was once the location for the county's almshouse, which was constructed in the 1860s by John O'Toole. O'Toole built a large 20-room, three-story mansion on 100 acres just outside Milpitas. His family lived in the home until 1882, when the mansion was sold to James Boyd. A year later, Boyd sold the land and mansion to Santa Clara County for $25,000. The county used the home to house the poor, while the surrounding land was used as a dairy, chicken, and hog farm. In 1957, the board of supervisors turned the old almshouse over to Sheriff Melvin Hawley to use as the new jail farm. (Courtesy Sourisseau Academy for State and Local History, San José State University.)

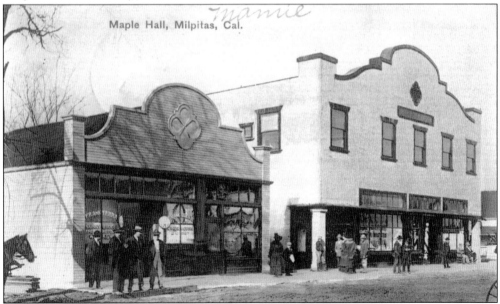

MILPITAS, MAPLE HALL, POSTMARKED MAY 2, 1912 (HAND-COLORED POSTCARD). Possibly one of the oldest remaining buildings on Main Street in Milpitas, Maple Hall (building on the right) looks nothing today as it did back in 1892, when it was built by the Paschote brothers. At the time, there was a dance floor and a meeting hall on the second floor, while the main floor housed a saloon, general store, and veterinary hospital. The building on the left was Frank Terra's General Store. (Published by E.P. Giacomazzi.)

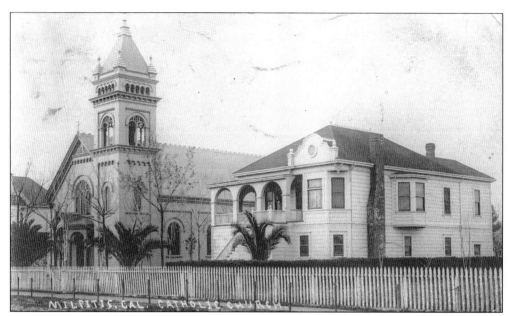

MILPITAS, CATHOLIC CHURCH, C. 1909 (REAL-PHOTO POSTCARD). The original St. John the Baptist Church was established in 1866 to serve the Portuguese immigrants who migrated to Milpitas, but it burned down in 1900. A second church, seen here, was constructed on the same location and in use until it was deemed unsafe and demolished in 1970. (Courtesy Sourisseau Academy for State and Local History, San José State University.)

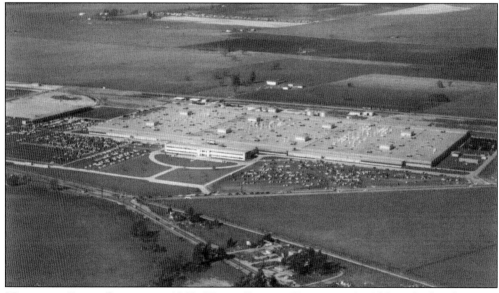

MILPITAS, FORD PLANT, C. 1960 (REAL-PHOTO POSTCARD). Although the plant was located rear Milpitas when it opened on May 17, 1955, the Ford Motor Company called it the San Jose Assembly Plant. Some of the cars made in Milpitas during its 28 years of production included the Mustang, Pinto, Falcon, Maverick, and F-Series pickup trucks. The plant closed on May 20, 1983. In 1994, the building reopened as the Great Mall of the Bay Area. (Published by Mike Roberts Color Prod., courtesy Sourisseau Academy for State and Local History, San José State University.)

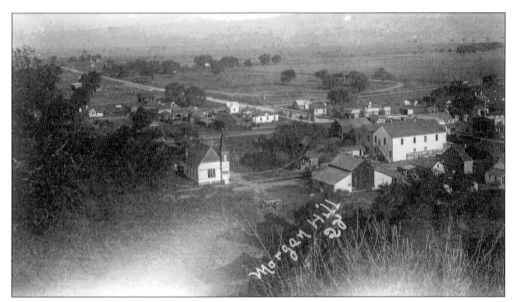

MORGAN HILL, TOWN VIEW, C. 1908 (REAL-PHOTO POSTCARD). Diana Murphy, granddaughter of Martin Murphy, an early pioneer to California and Santa Clara County, met and married Hiram Morgan Hill in 1882. When Diana's father, Daniel, died, she and Hiram inherited 4,500 acres near Murphy's Peak (now known as El Toro), and by the late 1890s, the community became known as Morgan Hill. (Courtesy the California History Room, California State Library, Sacramento, California.)

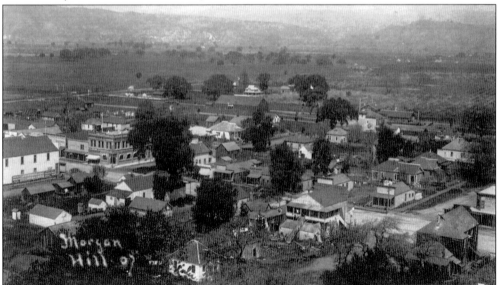

MORGAN HILL, TOWN VIEW, POSTMARKED JANUARY 24, 1908 (REAL-PHOTO POSTCARD). The town of Morgan Hill incorporated in November 1906. The first census for the town occurred in 1910, reporting a population of 607 people. Ten years later, in 1920, the population only grew by 39 people to 646. The 1940 census saw Morgan Hill with a population of 1,104, and in the 1960 census, 3,150 people. The years between 1970 and 1980 saw a 205 percent jump in population, from 5,579 people in 1970 to 17,060 in 1980. By 2010, the population doubled the 1980 figure, to 37,822.

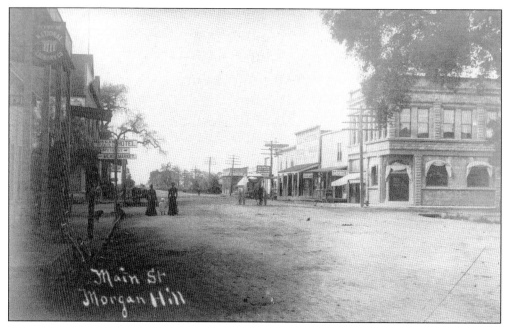

MORGAN HILL, MAIN STREET, C. 1908 (REAL-PHOTO POSTCARD). The Votaw Building (to the right) is located on the northeast corner of Monterey Road and Second Street. Constructed in 1905, it was home to the Bank of Morgan Hill and Bank of America until 1954. The Hotel Morgan Hill (seen on the left) burned to the ground due to an explosion of an oil lamp on October 14, 1909.

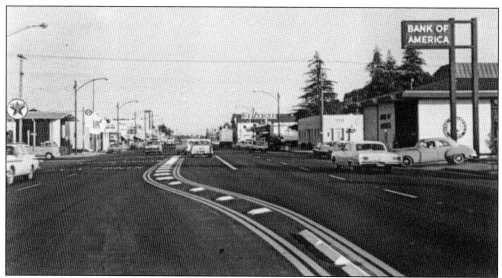

MORGAN HILL, MONTEREY STREET, C. 1960s (REAL-PHOTO POSTCARD). El Camino Real, US Highway 101, and Monterey Road were all names of the main street through Morgan Hill. In 1926, a large portion of the El Camino Real (the Royal Road), including the portions in Gilroy and Morgan Hill through to San Francisco, became part of the California highway system as Highway 101. In the early 1970s, Highway 101 was realigned east of Morgan Hill, causing many downtown businesses to close. (Photograph by L.E. Lindholm, published by Commercial Printers.)

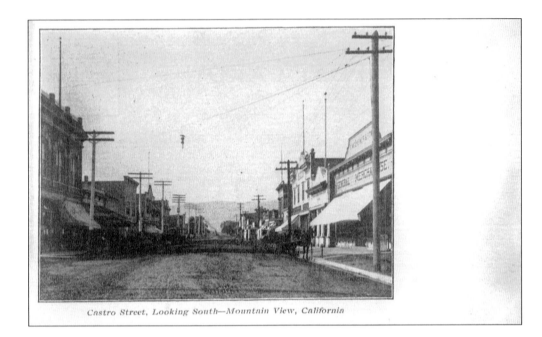

Castro Street, Looking South—Mountain View, California

ABOVE: MOUNTAIN VIEW, CASTRO STREET, C. 1905 (REAL-PHOTO POSTCARD); BELOW: MOUNTAIN VIEW, CASTRO STREET, C. 1910 (HAND-COLORED POSTCARD). By the late 1800s, Mountain View became a virtual boomtown, with hundreds of acres of land being planted with grains, hay, orchards, and vineyards. With the need for a modern downtown, most of Castro Street was graded and graveled, with concrete gutters and curbs added by 1904. Today, Castro Street is still the main downtown area, with fine dining, cafés, art galleries, and small quaint shops. (Below, published by E.T. Johnson.)

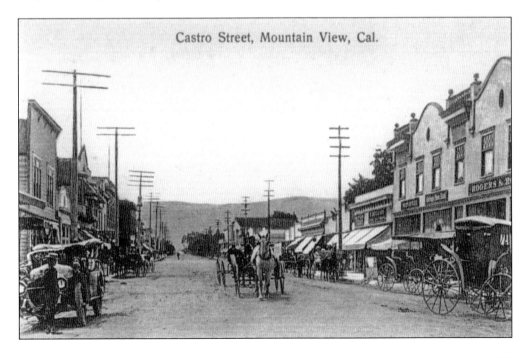

Castro Street, Mountain View, Cal.

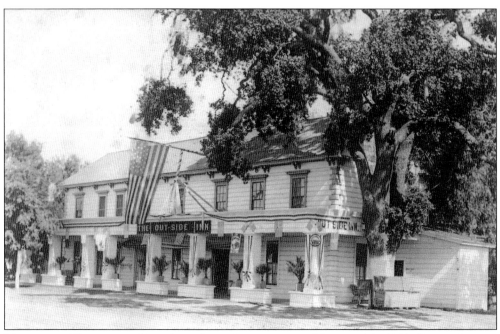

MOUNTAIN VIEW, THE OUT-SIDE-INN, POSTMARKED MARCH 21, 1911 (REAL-PHOTO POSTCARD). Also known as Taylors Hotel, it once stood on the El Camino Real near Grant Road in what is now known as Old Mountain View. It was also the stage stop for Mountain View. Almost exactly three months after this card was mailed, on June 22, 1911, the hotel was destroyed by a devastating fire.

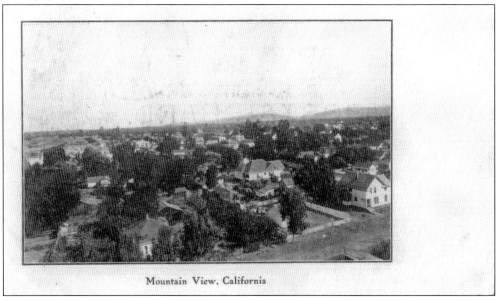

MOUNTAIN VIEW, BIRD'S-EYE VIEW, POSTMARKED NOVEMBER 25, 1905 (UNDIVIDED BACK POSTCARD). Originally, it was called Mountain View Station, due to the views of the Santa Cruz Mountains and it being a stage stop between the cities of San Jose and San Francisco. The town incorporated as Mountain View in November 1907 along San Jose Road (now the El Camino Real) and Phyllis Avenue in now what is called Old Mountain View.

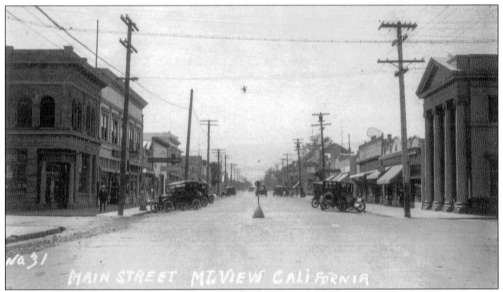

MOUNTAIN VIEW, MAIN STREET, POSTMARKED APRIL 20, 1925 (REAL-PHOTO POSTCARD).
The building on the left still stands today and is home to the Red Rock Coffee Company. Located on the southwest corner of Castro and Villa Streets, the building was constructed in 1905 and was once home to the Farmers and Merchants Bank. The columned building on the right was the First National Bank, constructed in 1911. The columns and pediment were removed in the 1950s.

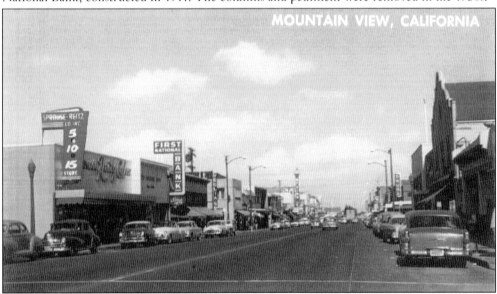

MOUNTAIN VIEW, CASTRO STREET, 1950S (REAL-PHOTO POSTCARD). In the 1880 census, Mountain View had a population of just 250 people. By 1910, the population grew to 1,161 and by 1930, to 3,308 people. As the agriculture side of Mountain View declined, the market for land to build homes and business skyrocketed. In 1950, with the beginnings of the building boom, Mountain View doubled the 1930s population, with 6,563, and by 1980, the population ballooned to 58,655. In the census of 2010, Mountain View's population reached 74,066, and by the city's own studies, Mountain View will add an additional 14,710 people by 2030. (Published by Milligan New Agency.)

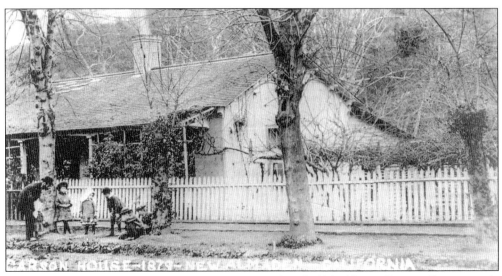

NEW ALMADEN, CARSON HOUSE, POSTMARKED MAY 9, 1947 (REAL-PHOTO POSTCARD).
The cottages along the creek side of Almaden Road were numbered 1 through 25, with the
Carson house being No. 13. Built sometime prior to 1850, it is one of only three adobe homes
remaining in New Almaden. George Carson came to New Almaden in 1883 and was employed
by the New Almaden Mining Company as its telegrapher, bookkeeper, and postmaster. The home
also served as the mining museum for many years before the museum moved to Casa Grande.

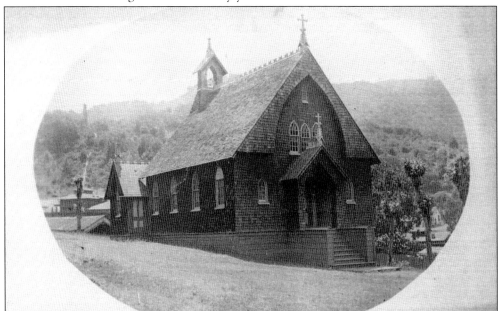

**NEW ALMADEN, ST. ANTHONY CHURCH, POSTMARKED JULY 17, 1908 (CYANOTYPE
POSTCARD).** Now known as the "Little Church," St. Anthony can trace its history back to 1859,
when the archbishop of San Francisco had the church constructed on Mine Hill in Spanishtown.
The original church, along with its predecessor, were destroyed by fire. The third church, the
one on the postcard, was constructed in 1885 on the same site as the previous two. When the
mines played out, the church was dismantled and, with the help of Senora Guadalupe Matera,
was moved and rebuilt on its current site in Almaden in 1899.

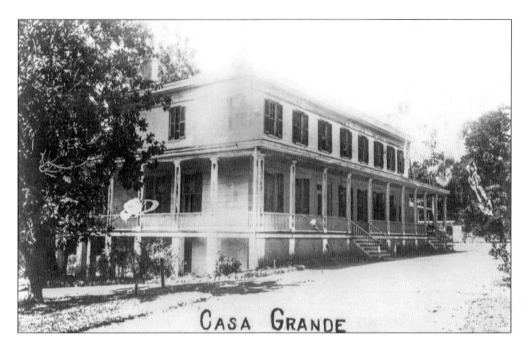

CASA GRANDE

ABOVE: NEW ALMADEN, CASA GRANDE, C. 1920S (REAL-PHOTO POSTCARD); BELOW: CLUB ALMADEN, POSTMARKED 1939 (ADVERTISING POSTCARD). Casa Grande, located in the Hacienda, was constructed in 1854 and served as the residence for the manager of the New Almaden Mining Company. In 1974, Santa Clara County purchased the Casa Grande, including the hills around the mines, creating the Almaden Quicksilver County Park. In 1997, after an extensive rehabilitation of the building, Casa Grande opened as the New Almaden Quicksilver Mining Museum. (Below, published by National Press, courtesy New Almaden Museum SCC Parks.)

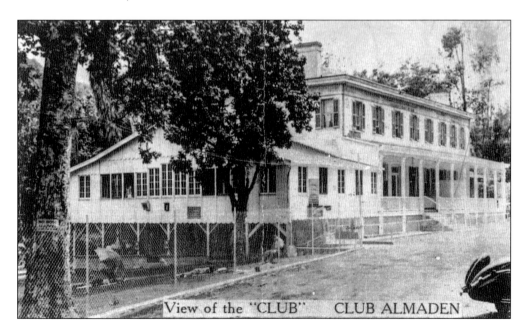

View of the "CLUB" CLUB ALMADEN

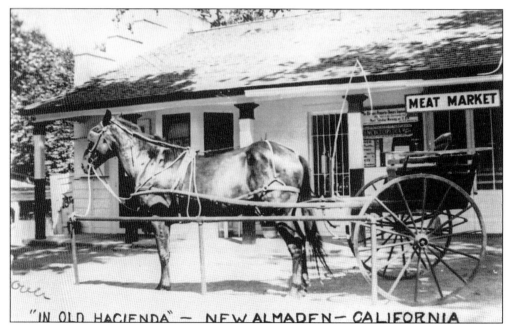

New Almaden, Old Hacienda, c. 1920 (Real-Photo Postcard). The Hacienda was built along Alamitos Creek and included Casa Grande, along with the homes of mine managers and furnace workers. It included a hotel, post office, general store, meat market, and later, a gas station. In 1973, a fire that began in Lou's Quicksilver Saloon destroyed the entire structure, including the post office, general store, and apartment buildings. (Courtesy New Almaden Museum SCC Parks.)

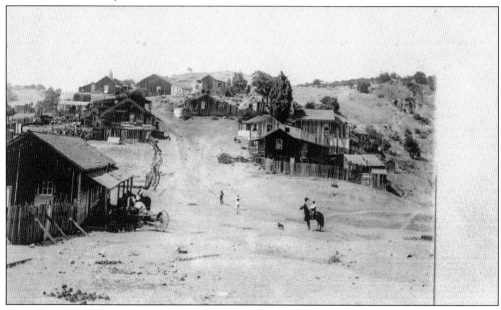

New Almaden, Spanishtown, c. 1907–1917 (Real-Photo Postcard). Spanishtown was the largest of the three communities in New Almaden and had a predominantly Mexican and Chilean population. The population began to decrease by the early 1900s, and most of the abandoned buildings were torn down by the 1930s. (Courtesy New Almaden Museum SCC Parks.)

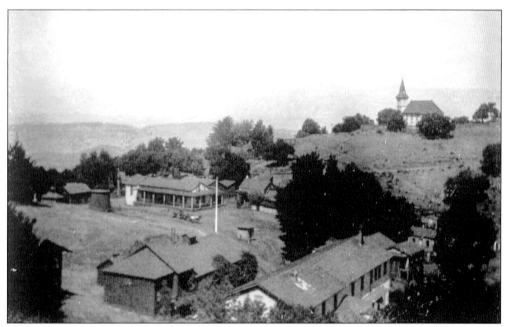

NEW ALMADEN, ENGLISHTOWN, C. 1906 (REAL-PHOTO POSTCARD). In the 1860s, English miners from Cornwall began arriving, establishing Englishtown. In the 1930s, the Civilian Conservation Corps set up in Englishtown and was tasked with demolishing the buildings in both Englishtown and Spanishtown. (Courtesy New Almaden Museum SCC Parks.)

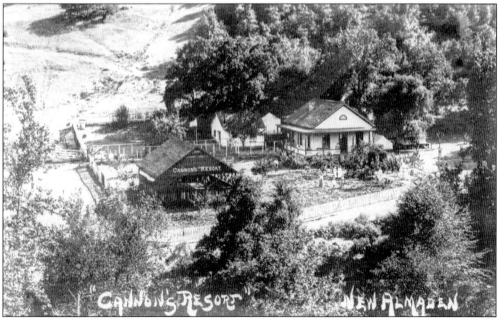

NEW ALMADEN, CANNON'S RESORT, C. 1910S (REAL-PHOTO POSTCARD). An advertisement from the July 5, 1917, edition of the *San Francisco Chronicle* describes what the resort offered: "Swimming, hunting fishing: dance hall; home cooking; daily mail. No tuberculars. Rooms and board $3.50 and $10. Floored tents $9.50 per week." The resort closed in the 1930s when Almaden Reservoir was built. (Courtesy New Almaden Museum SCC Parks.)

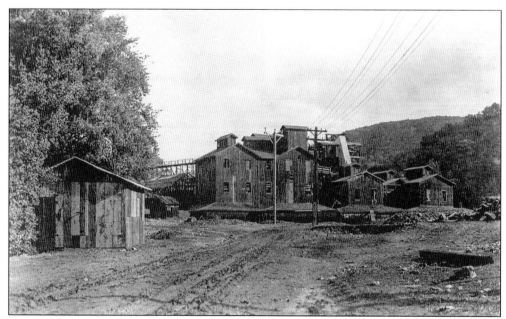

NEW ALMADEN, GUADALUPE MINE, C. 1907–1917 (REAL-PHOTO POSTCARD). Discovered in 1846, the mine enjoyed its peak years from 1854 to 1886, when it closed. The mine reopened in 1901 and ran intermittently until 1947, producing over 100,000 flasks of quicksilver. The town and mine site now sit under tons of refuse from the Guadalupe Landfill. (Courtesy New Almaden Museum SCC Parks.)

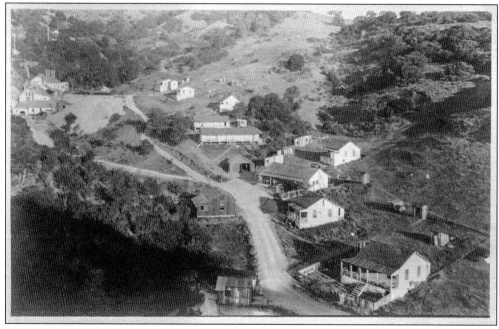

NEW ALMADEN, SENATOR MINE, C. 1907–1917 (REAL-PHOTO POSTCARD). Also known as the El Senator or Senador Mine, it opened in 1863 and was worked intermittently until 1926, when it shut down for good. Over its 63 years of activity, the mine produced over 20,000 flasks of quicksilver. (Courtesy New Almaden Museum SCC Parks.)

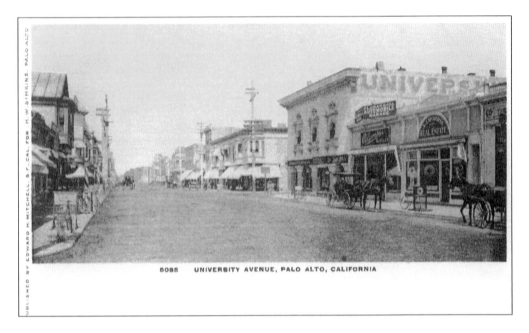

5085 UNIVERSITY AVENUE, PALO ALTO, CALIFORNIA

PALO ALTO, UNIVERSITY AVENUE, C. 1905 (UNDIVIDED BACK POSTCARDS). The city of Palo Alto officially incorporated on April 23, 1894, with the first census for the new city being conducted in 1910 with a population of 1,658. Ten years later, the population reached 5,900. In July 1925, the city annexed Mayfield, and by 1930, the population of the combined towns was 13,652 people. By 1940, there was only a modest gain to 16,774, but 20 years later, in 1960, the population ballooned to 52,287. Over the next 50 years, the population of the town only grew by about 9,000 people, to 64,403 in 2010. By 2020, it is projected that Palo Alto will have a population of 66,853 people. (Above, published by Edward H. Mitchell.)

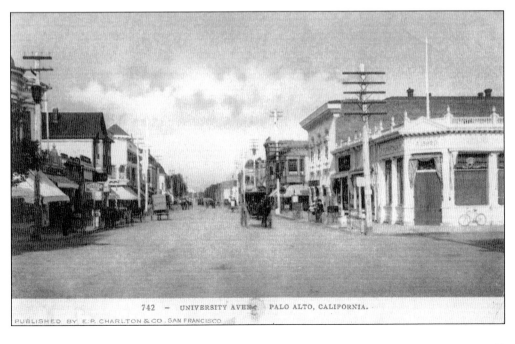

742 — UNIVERSITY AVENUE PALO ALTO, CALIFORNIA.

PUBLISHED BY E.P. CHARLTON & CO., SAN FRANCISCO

41

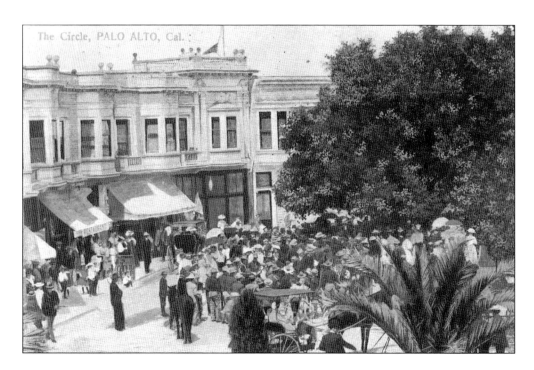

ABOVE: PALO ALTO, THE CIRCLE, POSTMARKED MARCH 27, 1909 (HAND-PAINTED POSTCARD); BELOW: PALO ALTO, THE CIRCLE, POSTMARKED SEPTEMBER 12, 1919 (REAL-PHOTO POSTCARD). The Circle was located at the intersection of University Avenue and Alma Street and was actually never finished as a circle, but as a half circle. It was considered the town square until 1941, when the Circle was removed to complete the intersection and railroad. (Above, published by Newman Post Card Co.; below, published by Hyde's Book Store.)

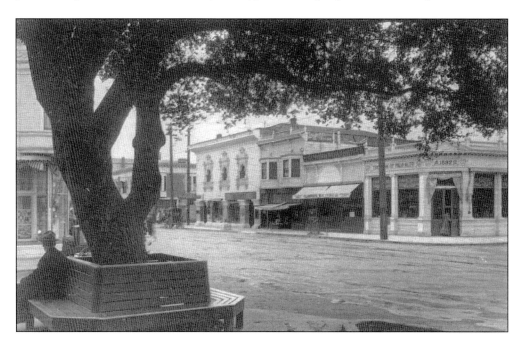

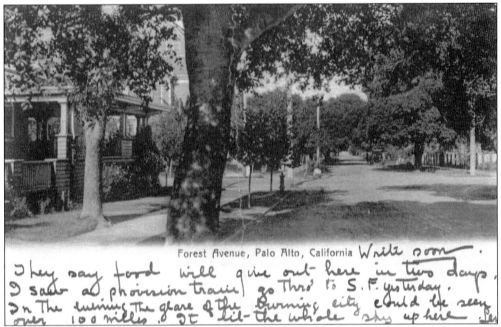

Forest Avenue, Palo Alto, California Write soon.

They say food will give out here in two days. I saw a provision train go Thro' to S. F. yesterday. In The evening The glare of the Burning city could be seen over 100 miles. It lit the whole sky up here.

FOREST AVENUE, POSTMARKED APRIL 21, 1906 (UNDIVIDED BACK POSTCARD). This postcard was sent to New York three days after the April 18, 1906, earthquake, and the writer tells a short story of his predicament: "They say food will give out here in two days. I saw a provision train go thro' to S.F. yesterday. In the evening glare of the burning city could be seen over 100 miles. It lit the whole sky up here." (Published by H.W. Simkins.)

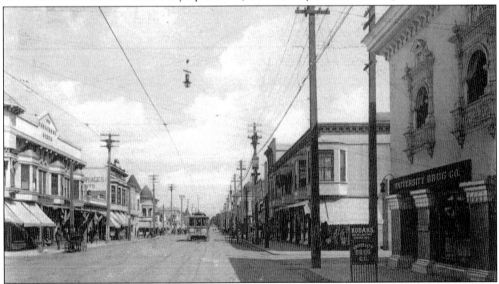

PALO ALTO, UNIVERSITY AVENUE, POSTMARKED APRIL 18, 1914 (DIVIDED BACK POSTCARD). In 1891, Stanford University held its first classes, and in 1894, the town of Palo Alto was formed just outside the university grounds. Palo Alto was a dry town upon its inception, where alcohol was totally banned until the 1950s, when some of the prohibitions were eased so some stores and restaurants could sell alcohol. But it was not until 1971 that the first "legal" drink was able to be served after the antialcohol laws were abolished. (Published by Hyde's Book Store.)

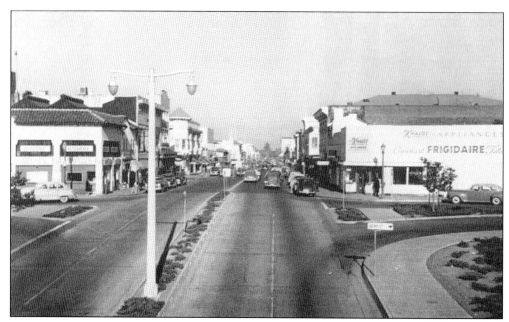

PALO ALTO, UNIVERSITY AVENUE, C. 1950S (DIVIDED BACK POSTCARD). Taken from the Alma Street overpass, this photograph has a view facing east down University Avenue and where the Circle once stood. The structure on the right was originally the Bank of Palo Alto, constructed in 1892. It also served as the Ames Photography studio and Knauss Appliance Store. The building was demolished to make room for a new office building. (Published by Mike Roberts Color Productions.)

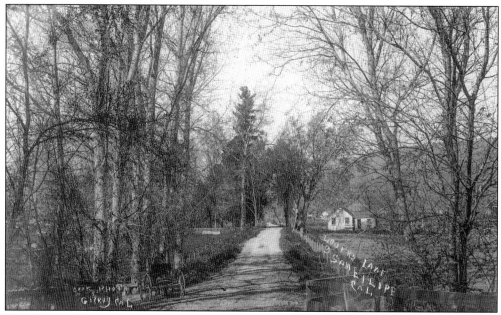

SAN FELIPE, LOVER'S LANE, POSTMARKED JUNE 31, 1909 (REAL-PHOTO POSTCARD). In the late 1880s, due to the many natural artesian wells in the area, the community of San Felipe became instrumental in providing water for irrigating crops in the south county area. Lovers' Lane is off of Highway 152 just north of San Felipe Road. (Published by Cook Photo.)

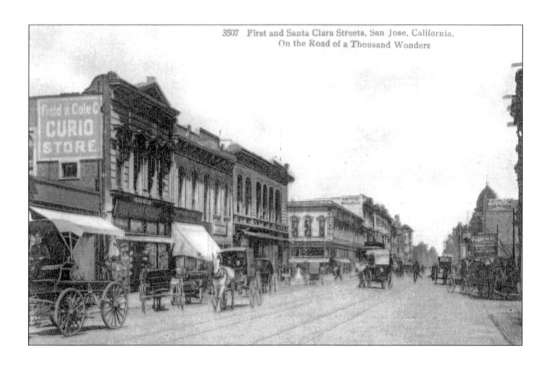

**ABOVE: SAN JOSE, FIRST AND SANTA CLARA STREETS, C. 1908 (DIVIDED BACK POSTCARD);
BELOW: SAN JOSE, SOUTH FIRST STREET, C. 1910 (DIVIDED BACK POSTCARD).** San Jose
was one of the stops "On the Road of a Thousand Wonders," a name coined by the Southern
Pacific Railroad to describe the 1,300-mile Coast Line–Shasta Route from Los Angeles in the
south to Portland, Oregon, in the north. (Both, published by Cardinell–Vincent Co.)

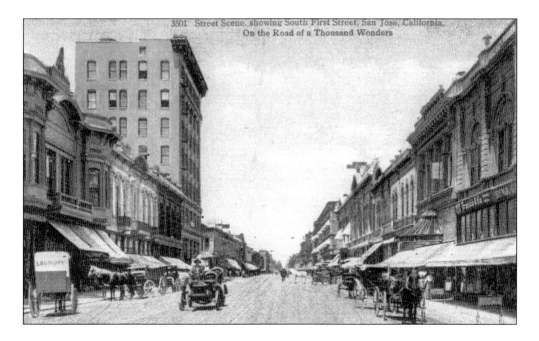

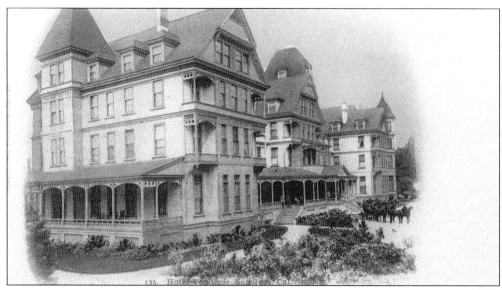

SAN JOSE, HOTEL VENDOME, C. 1900 (PRIVATE MAILING CARD). Looking to fill a need for a first-class hotel and resort, the Vendome Corporation was created and purchased 12 acres bordered by First, Hobson, San Pedro, and Empire Streets. The hotel opened to 55 guests on February 7, 1889. At a cost of $250,000, the four-story hotel included 150 rooms with en suite baths. Due to a growing demand for rooms, a 36-room annex was added in 1902. In the 1906 earthquake, the main hotel suffered minor damage, while the annex was a complete loss, with one person being killed. In 1930, the hotel was purchased by a real estate developer who demolished the grand hotel and sold the lots for $1,500 each.

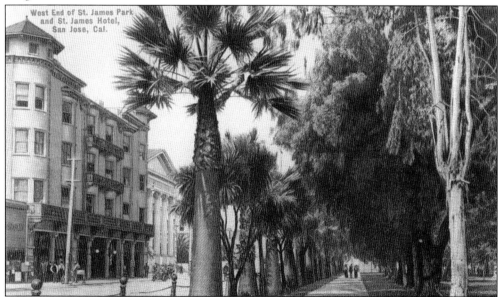

SAN JOSE, ST. JAMES HOTEL, C. 1907 (HAND-COLORED POSTCARD). Built entirely of brick and stone, the St. James Hotel opened on the corner of First and St. James Streets in 1870. The four-story hotel consisted of 225 rooms and was considered one of the most luxurious in San Jose. It was demolished in 1932 to make way for the new main post office building. (Published by M. Rieder, Publ.)

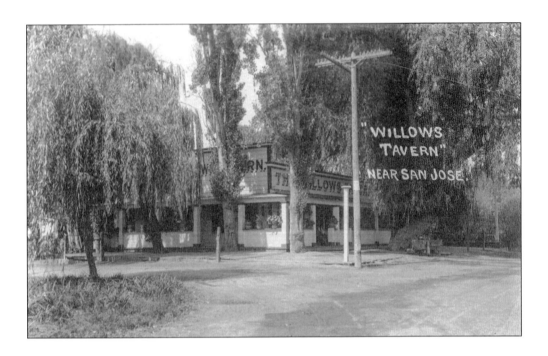

ABOVE: SAN JOSE, WILLOWS TAVERN, C. 1910, (REAL-PHOTO POSTCARD); BELOW: SAN JOSE, FILES TAVERN, C. 1905 (REAL-PHOTO POSTCARD). A series of advertisements in a *San Jose Mercury* of August 1919 announces, "Notice Come and Have a Good Time, Dancing Every Evening, Good Jazz Music and Refreshments, at the Willows Tavern Corner Montague and First Street, on the Alviso Road." (Above, courtesy the California History Room, California State Library, Sacramento, California; below, courtesy William A. Wulf.)

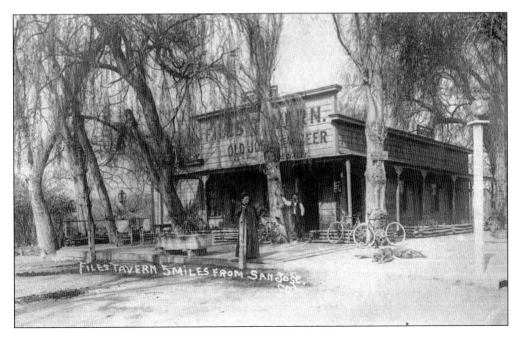

SAN JOSE, O'CONNOR'S SANITARIUM, POSTMARKED OCTOBER 14, 1908 (PANORAMA POSTCARD). O'Connor Hospital, then called O'Connor Sanitarium, was the first hospital in Santa Clara County. The hospital was built in 1889 by Judge Myles P. O'Connor and his wife,

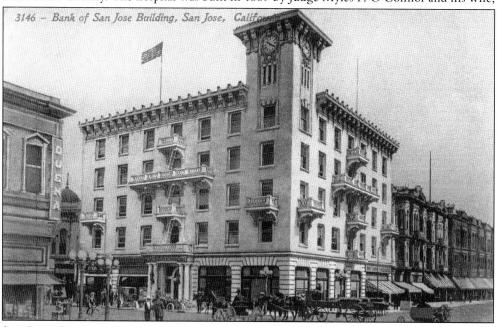

SAN JOSE, BANK OF SAN JOSE BUILDING, C. 1915 (DIVIDED BACK POSTCARD). The Bank of San Jose was the oldest bank in San Jose, having been founded in 1866. Located on the northwest corner of First and Santa Clara Streets, the original building was heavily damaged in the 1906 earthquake. The building was torn down and replaced with a five-story reinforced concrete structure. The Bank of Italy absorbed the Bank of San Jose in 1927 and was again renamed in 1945 to the Bank of America. (Published by Edward H. Mitchell.)

Amanda, on 15 acres at the corner of Race and West San Carlos Streets in San Jose. In 1955, O'Connor Hospital moved to its current site on Forest Avenue, with the old hospital being demolished in 1955. (Published by M. Rieder, Publ.)

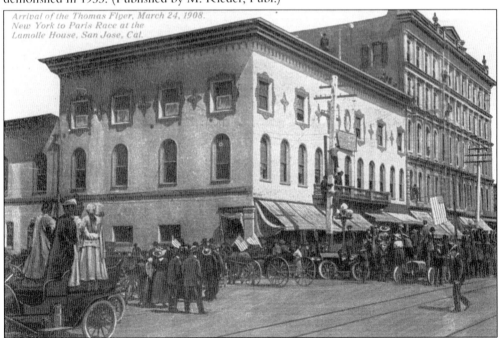

Arrival of the Thomas Flyer, March 24, 1908. New York to Paris Race at the Lamolle House, San Jose, Cal.

SAN JOSE, THOMAS FLYER, POSTMARKED DECEMBER 18, 1913 (DIVIDED BACK POSTCARD).
On February 12, 1908, six automobiles representing four countries left Times Square in New York City on a race around the globe that would take 169 days, cover 22,000 miles, and span three continents. The Thomas Flyer arrived in San Jose first on March 24, 1908, and eventually was one of only three cars that completed the race, crossing the finish line on July 30, 1908.

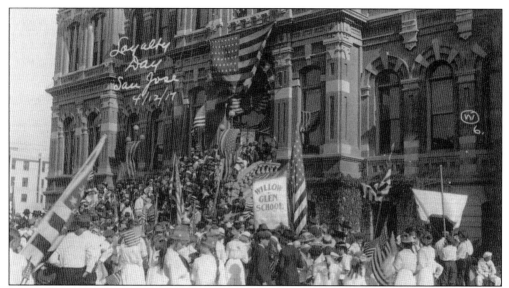

SAN JOSE, LOYALTY DAY, HAND-DATED APRIL 12, 1917 (REAL-PHOTO POSTCARD). Cities and towns of Santa Clara County united and showed their civic and patriotic pride on April 12, 1917, directed against the tyranny of the German Empire in World War I. More than 10,000 people, led by San Jose city manager Thomas H. Reed, marched through the streets carrying flags and banners of support.

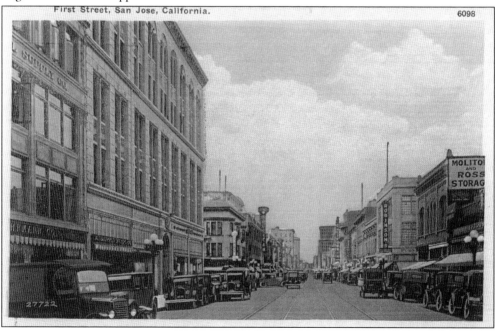

SAN JOSE, FIRST STREET, C. 1920S (HAND-COLORED POSTCARD). In this view looking north from South First Street, the building to the left, 325 South First Street, is the Dohrmann Hotel Supply Co. The next building at the corner with West San Carlos Street is now home to Original Joe's Restaurant. The Robinson Furniture building, middle right, eventually became Newberry's and was torn down to make room for the Robert F. Peckham Courthouse and Federal Building. (Published by Pacific Novelty Co.)

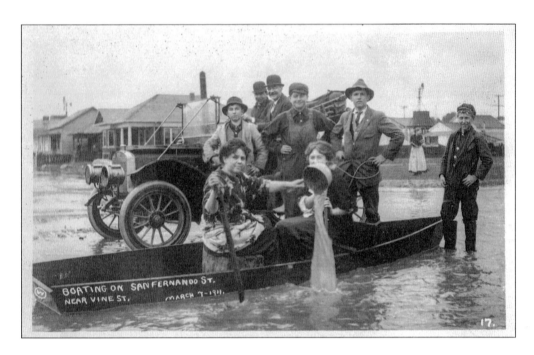

ABOVE: SAN JOSE, FLOOD OF 1911 (REAL-PHOTO POSTCARD); BELOW: FLOOD OF 1911, SOUTH FIRST STREET (REAL-PHOTO POSTCARD). In one of the worst floods in the history of San Jose and the Santa Clara Valley up to that time, San Jose saw almost 20 inches of rain through March. Flooding had also been reported from Alviso, Santa Clara, Saratoga, Los Gatos, and Campbell to Alum Rock Park. Mount Hamilton received "great quantities" of snow that when melted would add to the valley's flooding. (Above, courtesy the California History Room, California State Library, Sacramento, California; below, published by Webb's Photo.)

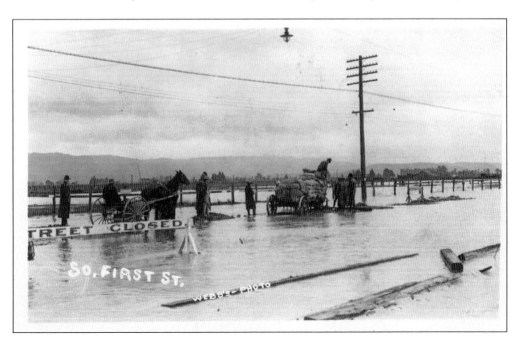

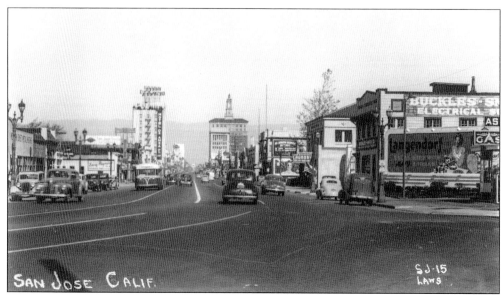

SAN JOSE, WEST SANTA CLARA STREET AT DELMAS AVENUE, C. 1940S (REAL-PHOTO POSTCARD). A view of West Santa Clara Street looks east from the Delmas Avenue intersection. The third building on the right (the old San Jose Water Works building at 374 West Santa Clara Street built in 1934) is the last remaining structure on either side of the street until the De Anza Hotel on the left. The buildings on the left are long gone, and the area is now part of the Guadalupe River Park, while the site of the buildings on the right is now a parking lot for the SAP Center. (Published by Casper Laws.)

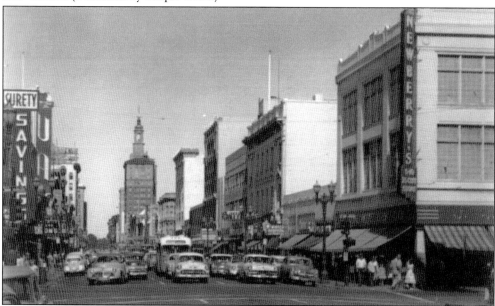

SAN JOSE, FIRST STREET, C. 1958 (CHROME POSTCARD). A view of First Street looks north from the intersection with San Carlos Street. Today, this intersection appears nothing like the scene in this postcard. The area around the Surety Savings is now a parking lot, and the Newberry's building was demolished to make way for the Robert F. Peckham Courthouse and Federal Building constructed in 1984. (Published by H.S. Crocker Co.)

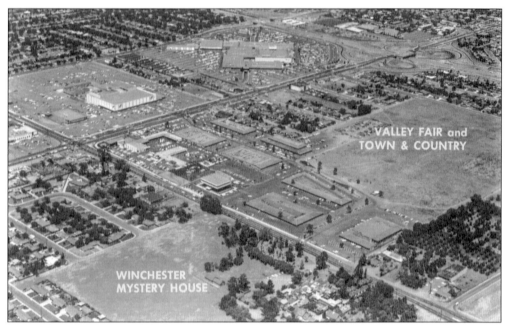

SAN JOSE, SHOPPING CENTERS, C. 1960 (REAL-PHOTO POSTCARD). An aerial view shows the shopping district at the intersection of Stevens Creek and Winchester Boulevards before the development of the Century Theaters in 1963. The large field with the Winchester Mystery House is the location of the now closed Century Theaters. Across the street is the old Town and Country Village, which was torn down in 1999 and replaced with Santana Row. The two buildings in the background are the original Valley Fair Shopping Center that opened in 1956. (Published by Milligan News Company.)

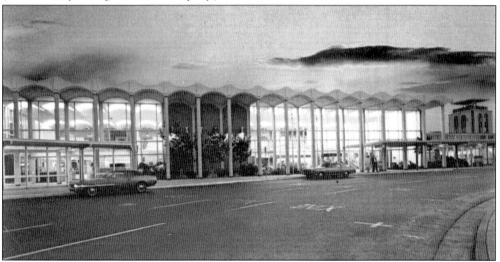

SAN JOSÉ AIRPORT, C. 1970s (REAL-PHOTO POSTCARD). Starting with 483 acres purchased from the Crocker family in 1939, San José Airport has grown from a single 4,500-foot runway to a major international airport with two 11,000-foot runways. The first airline servicing San Jose was Southwest Airways, using Douglas DC-3s on multi-stop flights between San Francisco and Los Angeles. The main terminal, later to be known as Terminal C (seen here), opened in 1965. (Published by Smith Novelty Co.)

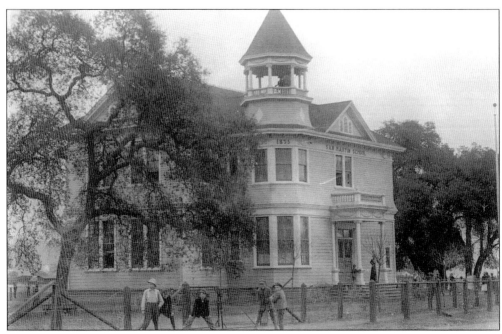

SAN MARTIN, SCHOOL, 1908–1912 (REAL-PHOTO POSTCARD). The two-story schoolhouse was constructed in 1895, the same year the San Martin School District was founded. In 1899, two students graduated from the school and were allowed to attend high school. The following school year, there were 60 students enrolled at the school. The old school building was replaced in 1922 with a single-story structure. (Courtesy Sourisseau Academy for State and Local History, San José State University.)

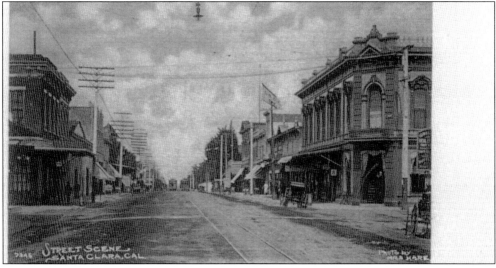

SANTA CLARA, STREET SCENE, C. 1905 (UNDIVIDED BACK POSTCARD). Following the onset of the gold rush in 1849, many turned to farming the fertile land surrounding the old mission rather than seeking their riches in the mines. A townsite was surveyed in 1850 by William Campbell, and lots were given to citizens who promised to build a home on their lot within three months. The town of Santa Clara was incorporated on July 5, 1852. (Published by Alice Hare, courtesy Santa Clara City Library.)

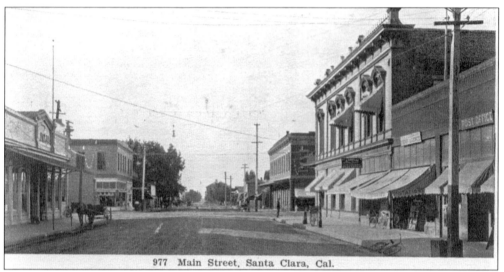

977 Main Street, Santa Clara, Cal.

SANTA CLARA, MAIN STREET, C. 1910 (DIVIDED BACK POSTCARD). Like the rest of the county, Santa Clara started off with a small population, mostly related to the farming community. In 1880, Santa Clara's population was only 2,416, and by the turn of the century, it only increased by 1,200 people to 3,650. Even by 1940, the population was reasonably small with 6,650 people. Over the next 20 years, especially between 1950 and 1960, the population skyrocketed to 58,880 as tracks of new homes were added at an ever-increasing rate. In the census of 2010, the city continued to grow, reaching a population of 116,468. With limited space to expand, Santa Clara's population is still expected to grow, and by 2020, the population is expected to reach 128,700, and by 2040, up to 156,500. (Published by Edward H. Mitchell.)

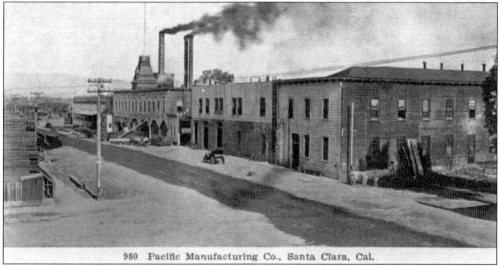

980 Pacific Manufacturing Co., Santa Clara, Cal.

SANTA CLARA, PACIFIC MANUFACTURING, C. 1910S (DIVIDED BACK POSTCARD). Starting out in 1875 as a small local lumberyard and planing mill in Santa Clara, Pacific Manufacturing grew its business throughout California, and on to Utah and the Hawaiian Islands. Originally known as the Enterprise Mill and Lumber Company, it started business on the corner of Bellamy and Union Avenues. Over the years, the company manufactured everything from lumber, sashes, and doors, to airplane parts and coffins. The business closed in 1960. (Published by Edward H. Mitchell.)

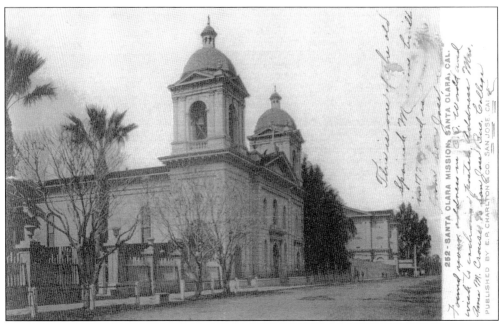

SANTA CLARA, MISSION, POSTMARKED NOVEMBER 26, 1906 (UNDIVIDED BACK POSTCARD).
Mission Santa Clara de Asís was the eighth mission in a chain of 21 Franciscan missions established by Padre Junípero Serra. Founded on January 12, 1777, on the banks of the Guadalupe River, the mission was moved to its current site in 1822 after floods and fire forced it to be relocated five times. In 1851, the Franciscan Order gave the mission to the Society of Jesus (the Jesuits), who then established Santa Clara College. (Published by E.P. Charlton & Co.)

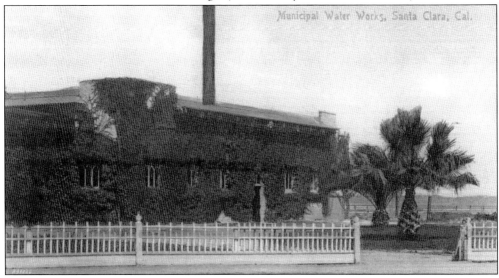

SANTA CLARA, MUNICIPAL WATER WORKS, C. 1905 (UNDIVIDED BACK POSTCARD).
Originally served by the San Jose Water Works, the town formed its own municipal waterworks in 1895 after breaking away from San Jose. At the turn of the century, a large tower with four water tanks stood near this building located on Benton Avenue, which provided much of the town's water. The tower was destroyed in the 1906 earthquake. (Published by Alice Hare, courtesy Santa Clara City Library.)

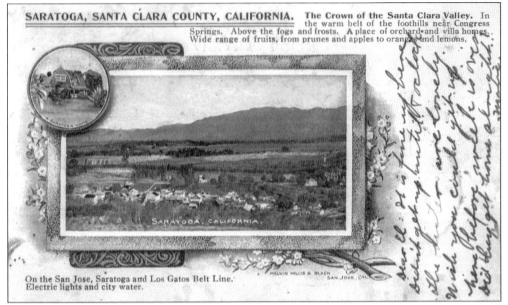

SARATOGA, SANTA CLARA COUNTY, CALIFORNIA. The Crown of the Santa Clara Valley. In the warm belt of the foothills near Congress Springs. Above the fogs and frosts. A place of orchard and villa homes. Wide range of fruits, from prunes and apples to oranges and lemons,

On the San Jose, Saratoga and Los Gatos Belt Line. Electric lights and city water.

SARATOGA, CALIFORNIA.

SARATOGA, TOWN VIEW, POSTMARKED SEPTEMBER 26, 1907 (UNDIVIDED BACK POSTCARD). Saratoga traces its history back to 1848, when a sawmill was constructed along what is now called Saratoga Creek. The original name of the community was Tollgate, after the toll road constructed by Martin McCarty. Next came McCartysville and Bank Mills, until the name Saratoga was settled on. Saratoga was named after a town in New York that had springs similar to those in its California namesake. (Published by Melvin Hillis and Black.)

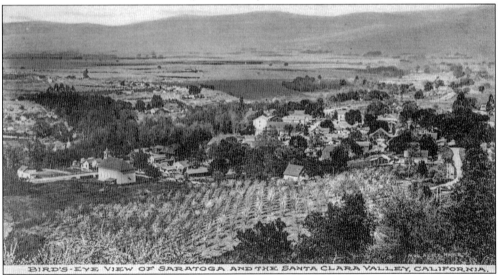

BIRD'S-EYE VIEW OF SARATOGA AND THE SANTA CLARA VALLEY, CALIFORNIA.

SARATOGA, BIRD'S-EYE VIEW, C. 1908 (HAND-COLORED POSTCARD). In the 1960 census, four years after incorporation, Saratoga's population was 14,861. Twenty years later, in 1980, the population had doubled to over 29,261. Since the 1980 census, Saratoga's population increases have been almost nonexistent. In the 2010 census, the population only gained a few hundred, reaching 29,926. The unofficial population for 2016 saw only a gain of just over 1,500 additional people, to 31,499—which is still a far cry from the 1880 population of 297. (Published by the Albertype Co.)

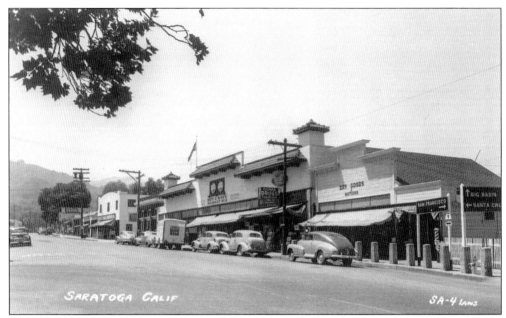

SARATOGA, DOWNTOWN, C. 1940S (REAL-PHOTO POSTCARD). The dry goods store is long gone and was replaced with a bank, while the Rexall Drug and Fountain has seen a number of changes over the years and is currently a restaurant. The Buy and Save Market is now a retail shop. Farther down the block, the brick building has been the Bank Cocktail Lounge for decades. (Published by Casper Laws.)

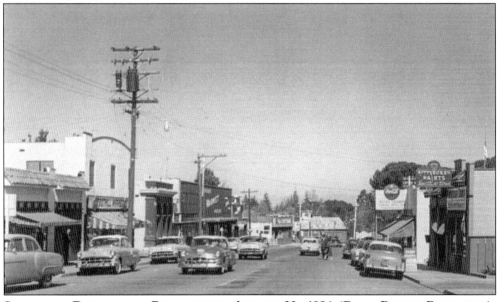

SARATOGA, DOWNTOWN, POSTMARKED AUGUST 22, 1956 (REAL-PHOTO POSTCARD). The description on the reverse of the postcard states, "Big Basin Way showing a portion of the business district. Formerly known as Lumber Street this thoroughfare carried timber from the Santa Cruz Mountains in the 19th century to the mills in the valley. The first lumber mill in Santa Clara County was located in Saratoga." (Photograph by Max Mahan, published by Columbia Wholesale Supply.)

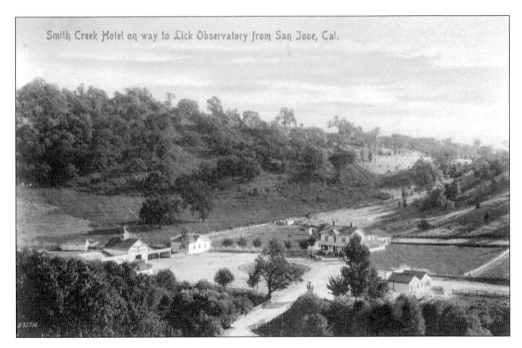

Smith Creek Hotel on way to Lick Observatory from San Jose, Cal.

ABOVE: SMITH CREEK, HOTEL, C. 1910 (DIVIDED BACK POSTCARD); BELOW: SMITH CREEK, HOTEL, POSTMARKED OCTOBER 11, 1913 (REAL-PHOTO POSTCARD). Constructed in 1895 by Thomas Snell, the hotel was located on the banks of Smith Creek on Mount Hamilton Road. It was the last of two stops along the 21-mile Mount Hamilton Road from San Jose to the Lick Observatory. Stage passengers had only 30 minutes to relax and eat dinner at the hotel while the exhausted horse teams were being exchanged for fresh horses. (Above, courtesy California Room, San José Public Library.)

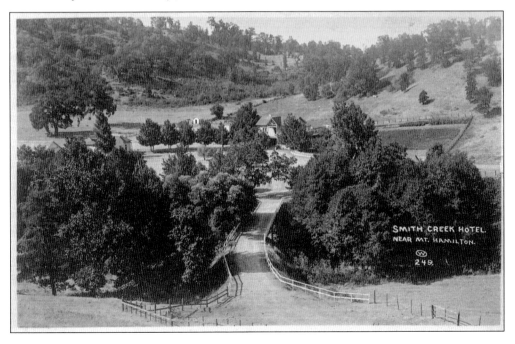

SMITH CREEK HOTEL.
NEAR MT. HAMILTON.
249

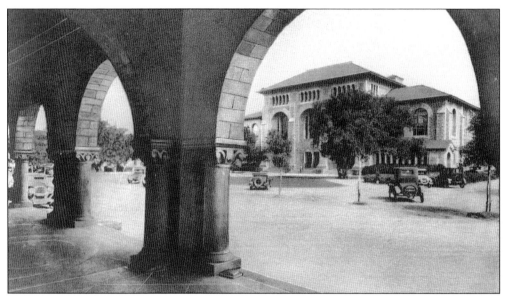

STANFORD UNIVERSITY, LIBRARY, C. 1910 (ALBERTYPE POSTCARD). Constructed to replace the library that was demolished by the 1906 earthquake, the Cecil H. Green Library opened in 1919 and is the largest of Stanford's 24 libraries. Green, founder of Texas Instruments, and his wife, Ida, were major contributors to the Stanford University libraries. (Published by Hyde's Book Store.)

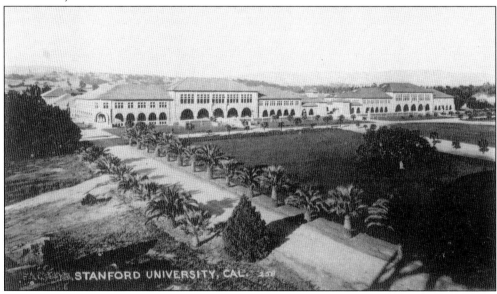

STANFORD UNIVERSITY, HAND-DATED JUNE 3, 1927 (REAL-PHOTO POSTCARD). Leland Stanford came to California from New York after the gold rush and purchased 650 acres of Rancho San Francisquito and began building his Palo Alto Stock Farm. By the time he purchased other adjoining properties, his stock farm had grown to more than 8,000 acres. Stanford was governor of California in 1862 and 1863 and senator from 1885 to 1893. In 1884, while he and his wife, Jane, were traveling in Italy, their 15-year-old son, Leland Stanford Jr., died of typhoid fever. Upon returning home, they decided to honor their son and established the university in his name. (Published by Pacific Novelty Co.)

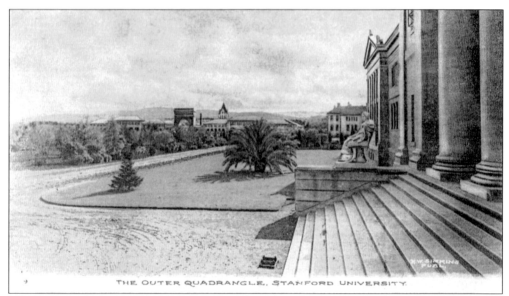

STANFORD UNIVERSITY, OUTER QUADRANGLE, C. 1904 (HAND-COLORED POSTCARD).
Stanford's main quads are the Inner Quad, or Quadrangle, and the Outer Quadrangle. The
Inner Quad is a large courtyard surrounded by 12 connecting buildings, as well as the Stanford
Memorial Church. The Outer Quadrangle is made up of 14 additional connecting buildings
that make up a number of smaller courtyards. (Published by the Albertype Co.)

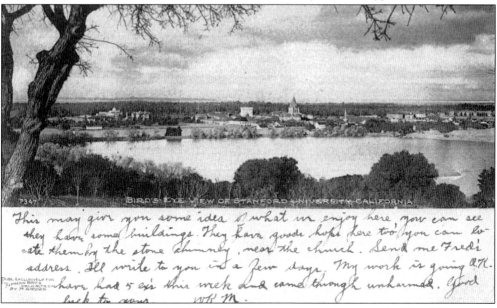

**STANFORD UNIVERSITY, BIRD'S-EYE VIEW, POSTMARKED OCTOBER 19, 1905 (UNDIVIDED
BACK POSTCARD).** Originally used to provide irrigation water for the Palo Alto Stock Farm in
the 1870s, Lake Laqunita saw many uses after the university took it over. In 1892, a boathouse
was built, and in 1898, the first bonfire was held for the big game, a tradition that lasted until
1997, when it was banned. In recent years, due to budget shortfalls and the high cost of filling
the lake, the university no longer uses the reservoir to stock water or for recreational purposes.
(Published by Tupman Bros.)

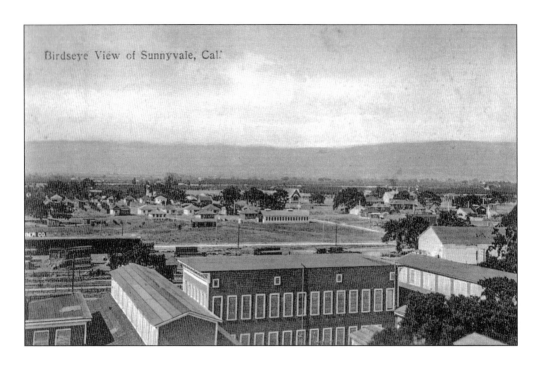

ABOVE: SUNNYVALE, BIRD'S-EYE VIEW, C. 1910 (DIVIDED BACK POSTCARD); BELOW: SUNNYVALE, POSTMARKED AUGUST 9, 1910 (DIVIDED BACK POSTCARD). Possibly taken from a water tank above the Hendy Iron Works, these photographs were taken north of the railroad tracks and features a view that looks south toward downtown Sunnyvale. (Above, published by Richard Behrendt; below, published by M.W. Dunningan.)

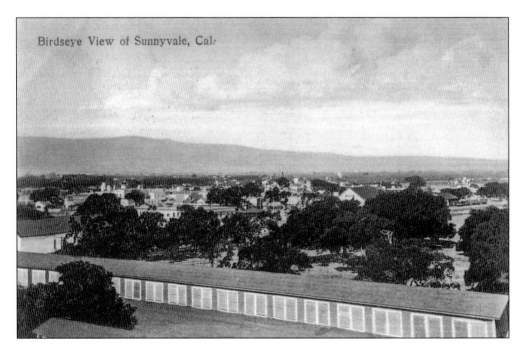

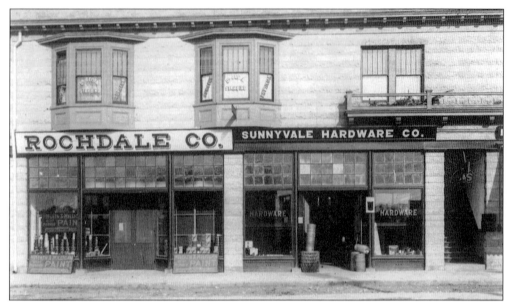

SUNNYVALE, S.S. BUILDING, C. 1906–1908 (REAL-PHOTO POSTCARD). Known as the S.S. Building for its two builders, it was constructed in 1907 by C.C. Spalding and C. Stowell. The Rochdale Co. Paint store was at 186 Murphy Avenue, which also served as the Tree Grocery in the 1920s and the Red & White Market in the 1930s. The Sunnyvale Hardware store at 190 Murphy Street closed and later became Kirk's Drug Store in the 1930s. (Courtesy California Room, San José Public Library.)

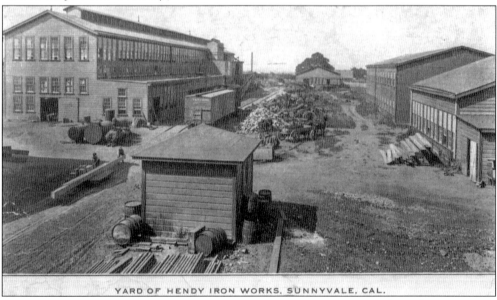

YARD OF HENDY IRON WORKS, SUNNYVALE, CAL.

SUNNYVALE HENDY IRON WORKS, POSTMARKED NOVEMBER 26, 1909 (REAL-PHOTO POSTCARD). Joshua Hendy founded his ironworks in San Francisco in 1856, manufacturing equipment for the mining industry. After a fire destroyed the factory in 1906, the business was relocated to Sunnyvale with the offer of free land to build on. With the onset of World War II, Hendy Iron Works went from 40 employees in 1940 to over 11,500 by 1945. (Published by the Polychrome Co.)

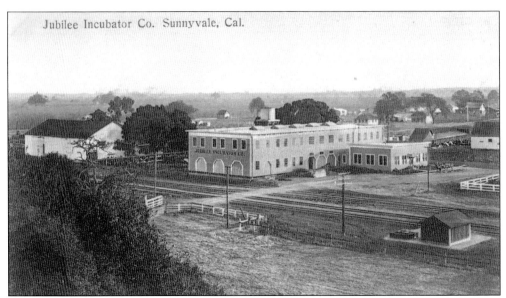

SUNNYVALE, JUBILEE INCUBATOR CO., C. 1910 (HAND-COLORED POSTCARD). In business since 1882, the Jubilee Incubator Company moved to Sunnyvale from Oakland in 1907. Located on the southeast corner of Evelyn and Sunnyvale Avenues, the plant manufactured incubators, brooders, and poultry supplies. The Great Depression hit the company hard, forcing it into bankruptcy. The facility was demolished in 1983 to make way for new development. (Published by C.W. Stubbs.)

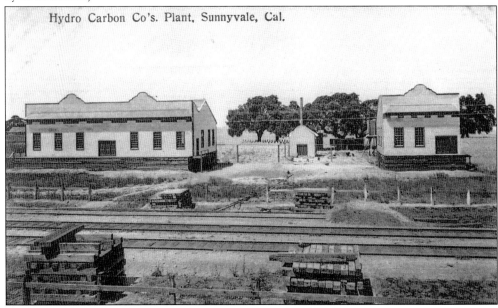

SUNNYVALE, HYDRO CARBON COMPANY PLANT, C. 1910 (DIVIDED BACK POSTCARD). The Hydro Carbon Company began business around 1900 and, with investments from local farmers, manufactured paraffin paints, varnishes, and lacquers. It was located near the Hendy Iron Works on the north side of the railroad tracks just west of Fair Oaks. In 1942, the plant was bought out by Hendy Iron Works, which was subsequently purchased by Westinghouse in 1957. (Published by Richard Behrendt.)

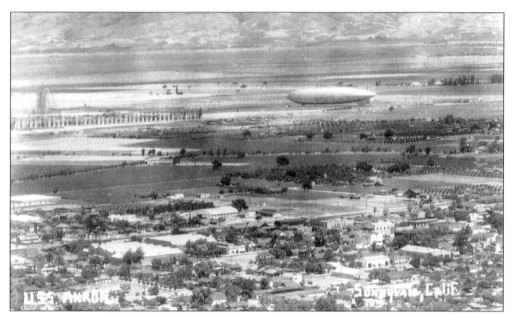

SUNNYVALE, USS *AKRON*, C. 1932 (REAL-PHOTO POSTCARD). Six months after its maiden voyage, the USS *Akron* made its first, and last, coast-to-coast flight, landing in Sunnyvale on May 13, 1932. Less than a year later, on April 3, 1933, the Akron cast off from New England, crashing early the next morning into the stormy Atlantic Ocean, killing 73 of the 76 crewman and passengers.

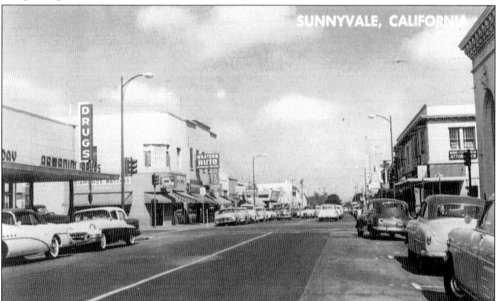

SUNNYVALE, MURPHY AVENUE, C. 1950S (REAL-PHOTO POSTCARD). This street was named after Martin Murphy Jr., who came to California with his father in 1844 as part of the Stephens-Townsend-Murphy Party. In 1850, he purchased a section of an earlier land grant for $12,500 and set up a wheat farm. The area became known as Murphy, but in 1901, when the post office advised the community could not use the name Murphy, it adopted the name Sunnyvale. (Published by Columbia Wholesale Supply.)

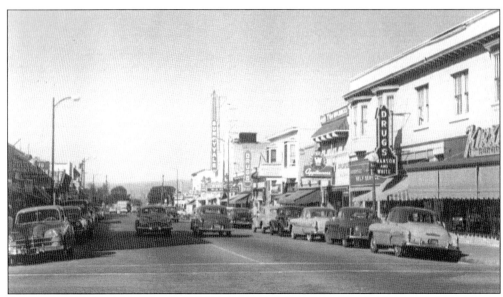

Sunnyvale, Murphy Avenue, c. 1950s (Real-Photo Postcard). With its humble beginnings as a small farming community, Sunnyvale grew slowly but steady until the 1960s, when high tech came to the valley and especially Sunnyvale. After Sunnyvale's incorporation in 1912, its first census was in 1920, with a population of 1,675. Twenty years later, in 1940, the population reached only 4,373, but 1960 saw the largest increase, to 95,976, which was partially due to Lockheed moving to Sunnyvale in 1956. The population has increased steadily over the years, and in the census in 2010, Sunnyvale's population reached 140,095. (Published by Milligan News Agency.)

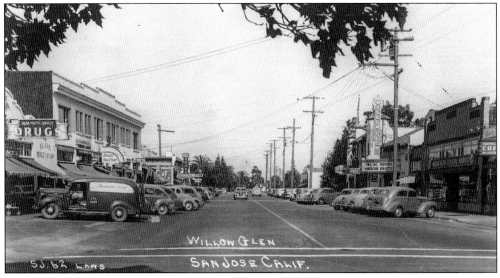

Willow Glen, Lincoln Avenue, c. 1940s (Real-Photo Postcard). With roots dating back to the mid-1800s, Willow Glen incorporated in 1927 when the Southern Pacific Railroad threatened to run a rail line down the middle of Lincoln Avenue. With no citywide sewage system available, the town voted 978 to 871 in 1936 in favor of annexing into San Jose as a solution to its sewage problem. (Courtesy the California History Room, California State Library, Sacramento, California.)

Two

Santa Cruz Mountain Communities
Lost Towns in the Mountains

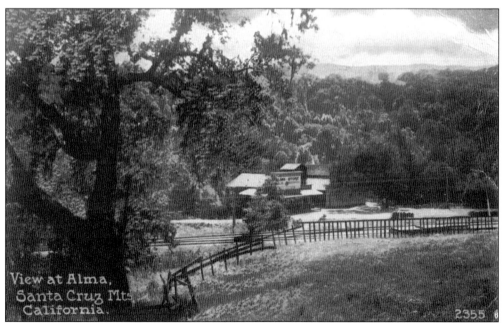

Alma, Town View, Postmarked July 27, 1914 (Real-Photo Postcard). The old town now lies beneath the waters of Lexington Reservoir. When the water levels are down, visitors can still see a few foundations and an old bridge dating from 1923. Originally called Forest House, the town changed its name to Alma in 1873. By the time the James J. Lenihan Dam was constructed in 1952, the town had less than 100 people living in it. (Published by Souvenir Publishing Co.)

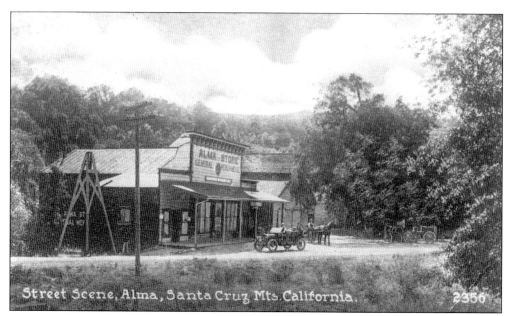

ALMA, STREET SCENE, POSTMARKED JUNE 1914 (DIVIDED BACK POSTCARD). George Osmer came to Alma from San Francisco around 1889 and began as a clerk in the town's only general store. In 1890, he became Alma's postmaster and, a few years, later bought half interest in the store. Five years later, he bought the remaining half of the business from a Mr. Bohme and became its sole proprietor. (Published by Edward H. Mitchell.)

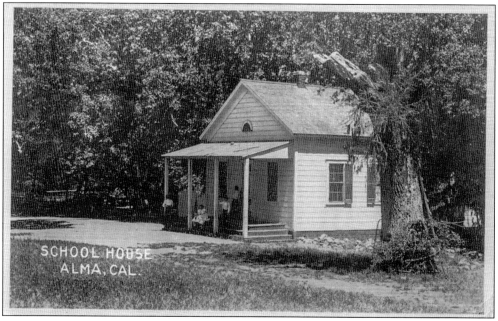

ALMA, SCHOOLHOUSE, POSTMARKED APRIL 8, 1914 (REAL-PHOTO POSTCARD). The first school in the area was constructed in Lexington, but the town of Alma had a larger population, so the school was torn down and relocated about a mile south to Alma in 1911. Due to the building of Lexington Reservoir in 1952, Lexington School was again moved, to its current location on Old Santa Cruz Highway. (Courtesy William A. Wulf.)

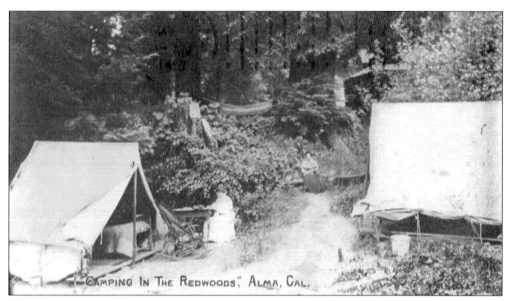

ALMA, CAMPING IN THE REDWOODS, POSTMARKED MAY 28, 1910 (REAL-PHOTO POSTCARD). Alma was a popular stop along the Southern Pacific Coast Railroad for campers and family picnics. An article from the *San Jose Mercury* dated June 4, 1905, notes, "The Cambrian School children and their friends enjoyed a picnic near Alma May 27. A large wagon conveyed most of the children to the grounds where a picnic lunch, with coffee and ice cream was served." (Published by California Postal Card Co.)

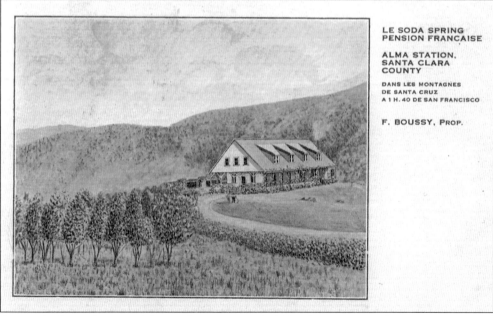

ALMA, LE SODA SPRINGS, HAND-DATED JULY 19, 1918 (ADVERTISING POSTCARD). Trained as a chef in Paris, Ferdinand Boussy emigrated to the United States in 1907. Soon after arriving, Boussy purchased 72 acres on Soda Springs Road above Alma and built the Soda Springs Hotel. His French dinners became extremely popular with guests arriving from all over the Bay Area. (Courtesy William A. Wulf.)

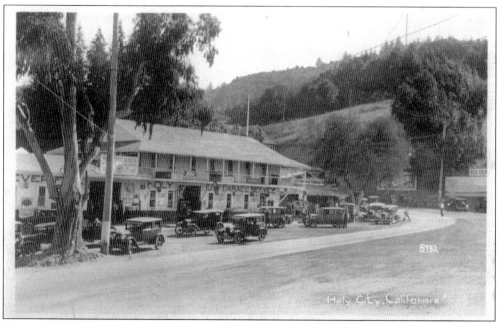

HOLY CITY, GARAGE, C. 1930S (REAL-PHOTO POSTCARD). Founded by cult leader William E. Riker, Holy City was founded in 1919 on 142 acres along what is now the old Santa Cruz Highway. The town was incorporated in 1924 and included a garage, gas station, restaurant, radio station, and a number of homes for its 300 residents. With the opening of Highway 17 in the 1940s, Holy City declined in popularity and finally was disincorporated in 1959.

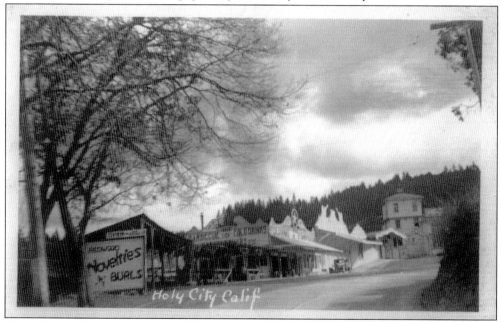

HOLY CITY, MAIN STREET, C. 1930S (REAL-PHOTO POSTCARD). One of Father Riker's directives for living in Holy City was that spouses were not allowed to live together, which led to a decline in population. This is also the reason no babies were ever born in Holy City. By 1938, only 79 people lived in Holy City; 75 were men, and only 4 were women.

HOLY CITY, KFQU RADIO TOWER, C. 1920S (REAL-PHOTO POSTCARD). KFQU was Father Riker's personal radio station, licensed in 1924 with 1,420 kilocycles and 100 watts. In 1931, the Federal Radio Commission permanently shut down the station on the grounds that it "was not operated in the public interest and had frequently deviated from its assigned frequency." (Courtesy William A. Wulf.)

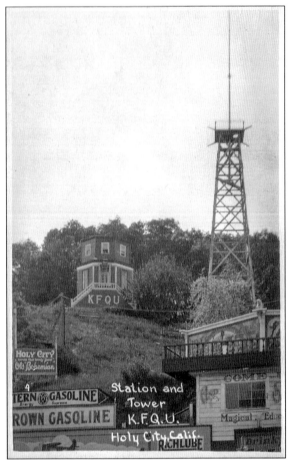

HOLY CITY, MAIN STREET, C. 1940 (REAL-PHOTO POSTCARD). Father Riker was charged with sedition in the 1940s for supporting Adolf Hitler, and in 1959, his town burned to the ground after a series of suspicious fires. A few scattered buildings still remain in Holy City, including a 1960s-era structure that once was home to a bar and the Holy City Art Glass store. Riker died on December 3, 1969, at the age of 96 at the Agnew State Hospital. (Published by Glen Arbor Novelty, courtesy William A. Wulf.)

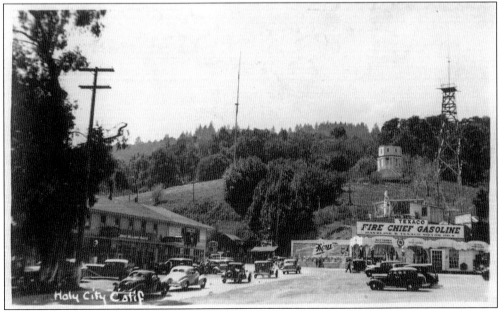

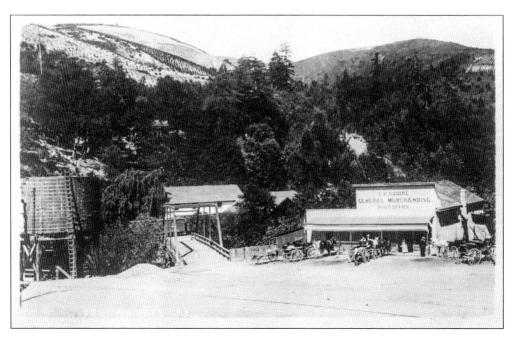

ABOVE: WRIGHTS, TOWN VIEW, POSTMARKED JUNE 20, 1910, (REAL-PHOTO POSTCARD); BELOW: WRIGHTS, TOWN VIEW, C. 1910 (REAL-PHOTO POSTCARD). Named after James Richards Wright, the small community built around a railroad stop along the South Pacific Coast Railroad became known as Wrights or Wrights Station. The town had a post office in 1879, while the tunnel running through the mountain opened in 1880. Southern Pacific closed the freight office at Wrights in 1934, and the post office closed in 1938. (Both, courtesy William A. Wulf.)

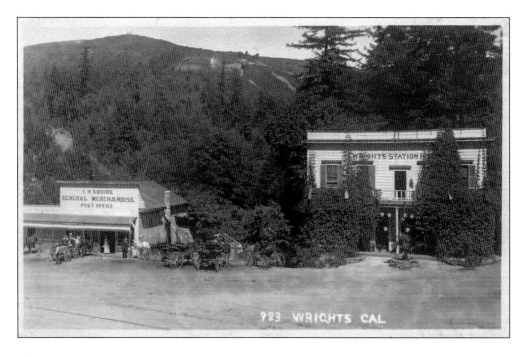

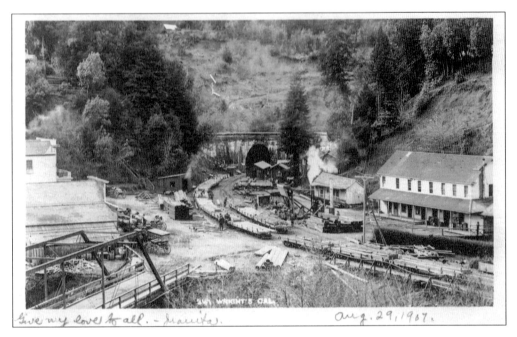

Give my love to all. — Mautta. *aug. 29, 1907.*

ABOVE: WRIGHTS, TOWN VIEW, POSTMARKED AUGUST 29, 1907 (REAL-PHOTO POSTCARD); BELOW: WRIGHTS, LUMBER, POSTMARKED JUNE 23, 1907 (REAL-PHOTO POSTCARD). Following the April 18, 1906, earthquake, Wrights became almost impossible to reach. Roads leading to town were impassable due to landslides, and the railroad tunnels had collapsed. It was well over a year before railroad traffic was able to safely travel over the tracks again. The two postcards seen here shows lumber being brought in to construct a new station across the creek from town.

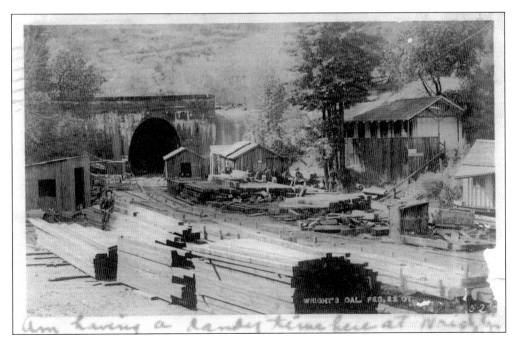

Am having a dandy time here at Wrights

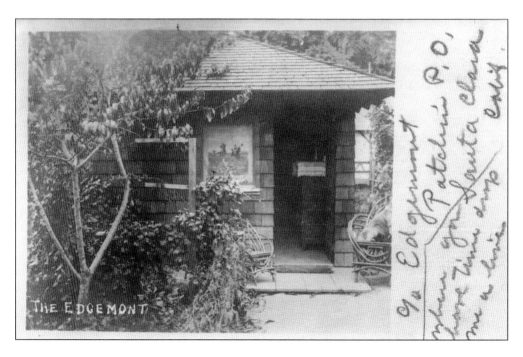

ABOVE: PATCHIN, THE EDGEMONT, POSTMARKED JUNE 1911, (REAL-PHOTO POSTCARD); BELOW: THE EDGEMONT c. 1910 (REAL-PHOTO POSTCARD). Once a stop along the main highway to Santa Cruz from San Jose, Patchin is considered a ghost town, but it is now home to numerous Christmas trees farms. The town's post office opened in 1872, with the Edgemont Hotel dating back to the 1880s. It was operated by L.N. Scott and his wife and was located on the west side of the road where the main parking lot for the Christmas tree farm is today. (Below, courtesy William A. Wulf.)

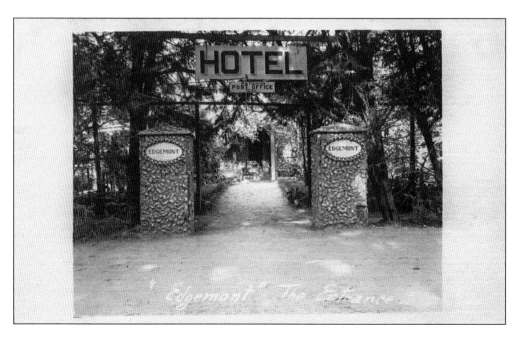

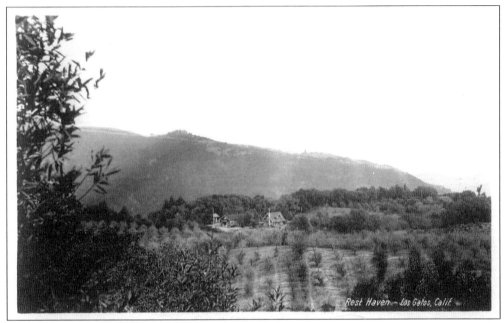

LOS GATOS, REST HAVEN, POSTMARKED JULY 6, 1923 (REAL-PHOTO POSTCARD). The building on the left is still standing today and was the second Lakeside schoolhouse. The original schoolhouse was constructed in the 1880s on land donated by the Thompson family—the same family the nearby road is named after. Within a few short years, the school was overwhelmed by the number of students in attendance. In 1917, the old school was moved 40 feet to a new site and was used as a home for the schoolteacher. A larger new school was then constructed on the site of the old schoolhouse.

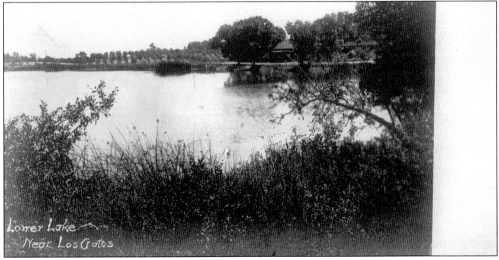

LOS GATOS, LOWER LAKE, C. 1910 (DIVIDED BACK POSTCARD). The actual location of this lake is not known, but it could possibly be Lower Howell Reservoir. In the 1870s, the San Jose Water Company began constructing small reservoirs in the Santa Cruz Mountains and, in 1877, built Upper Howell Reservoir off Black Road. Five years later, Lower Howell Reservoir was constructed. Both lakes have been renamed after early water company executives: the upper reservoir is now known as Lake Kittredge, and the lower one is Lake Couzzens.

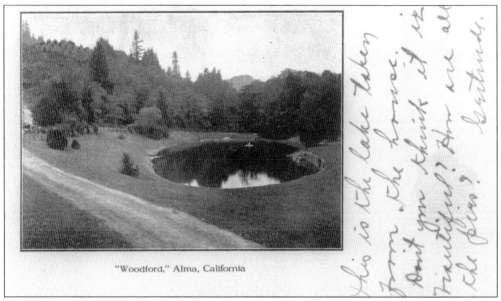

This is the lake taken from the house. Don't you think it is beautiful? How are all the pins? Gertrude.

"Woodford," Alma, California

ABOVE: ALMA, WOODFORD, POSTMARKED JANUARY 6, 1911 (UNDIVIDED BACK POSTCARD); BELOW: ALMA COLLEGE, POSTMARKED DECEMBER 7, 1940 (REAL-PHOTO POSTCARD). In early 1906, Dr. Lloyd Tevis purchased 800 acres along with a 40-room villa above the town of Alma on Bear Creek Road. After the 1906 earthquake destroyed the home, Tevis rebuilt the estate in a Swiss chalet style. In 1934, the estate was purchased by the California Province of the Society of Jesus, who converted the property to Alma College as a school of theology. One of the most famous students of the Jesuits was Jerry Brown, who later became the governor of California. After the school closed in 1969, the property was leased as a private Christian school and eventually was sold to a Hong Kong developer who envisioned a golf course and clubhouse on the site. In 1999, the Midpeninsula Regional Open Space District bought the property with the intent to open it to the public. (Both, courtesy William A. Wulf.)

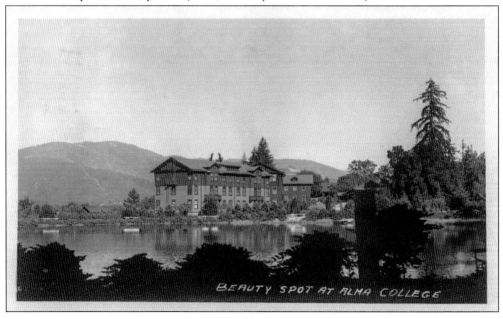

ALMA, CREEK SCENE, POSTMARKED JULY 29, 1906 (UNDIVIDED BACK POSTCARD). Before rivers and creeks were dammed or diverted for irrigation, fishing had always been a popular sport in the county. An article from the *San Jose Evening News* of April 6, 1901, relates one such story: "Another fine string of trout was caught by Wm. Morris and Fred Miller in the Los Gatos Creek Between Alma and Wrights. Mr. Morris had 86 trout that ranged from 6 to 9 inches while his companion had 33 to his credit."

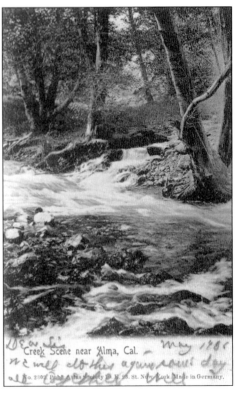

Creek Scene near Alma, Cal.

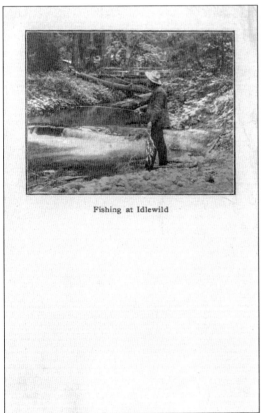

Fishing at Idlewild

IDLEWILD, FISHING, POSTMARKED AUGUST 10, 1909 (REAL-PHOTO POSTCARD). Idlewild is a small community between Alma and Wrights that once had a small Southern Pacific Coast Railroad depot. A note on the back of the card reads, "Lots of poison oak and lovely ferns are all I can say for the place." (Courtesy William A. Wulf.)

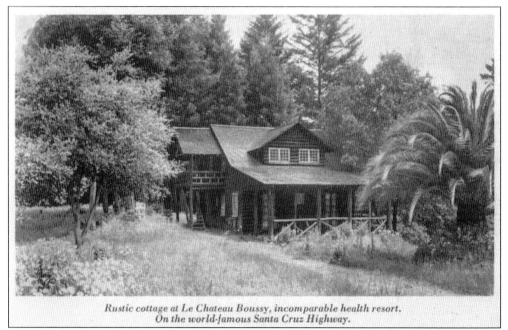

Rustic cottage at Le Chateau Boussy, incomparable health resort.
On the world-famous Santa Cruz Highway.

LA CHATEAU BOUSSY, C. 1920S (ADVERTISING POSTCARD). Located on the Santa Cruz Highway above Alma, Chateau Boussy started as a Wells Fargo stage stop in 1865. With the success of the Le Soda Springs Hotel, Boussy wanted to expand his business and purchased the property, opening Le Chateau Boussy resort in the early 1920s. Billed as a health resort with several cabins and hotel, it featured a restaurant that was well known for its fine French cuisine. Local lore also claims it was a speakeasy during Prohibition. (Courtesy William A. Wulf.)

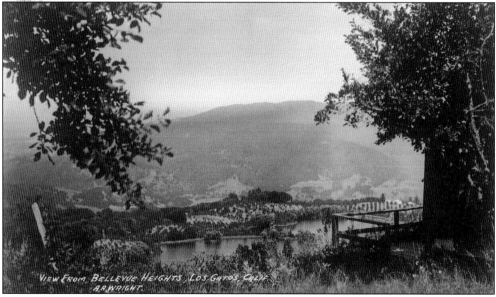

LOS GATOS, BELLEVUE HEIGHTS, C. 1920S (REAL-PHOTO POSTCARD). Billed as the "Switzerland of the Santa Cruz Mountains," Bellevue Heights opened in the 1920s as a health resort high atop Thompson Road above Alma. The 11-acre site still has five original cottages on the property and, as of July 2017, was for sale at $2.7 million. (Courtesy William A. Wulf)

Three

Parks and Recreation
Having Fun and Relaxing

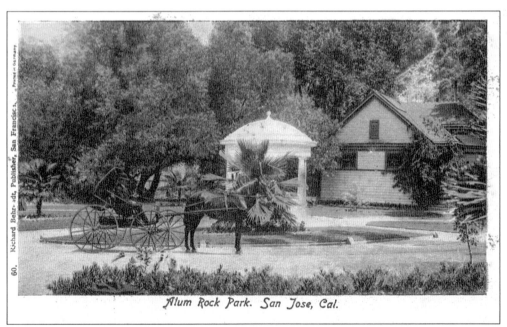

Alum Rock Park. San Jose, Cal.

Alum Rock Park, c. 1905 (Undivided Back Postcard). In the early days, local residents would flood to the park to enjoy the 27 mineral springs, along with a number of other attractions. Crowds came to see weekend concerts, eat at the park's restaurant café, swim in the large heated pool, or soak in the bathhouse. The park also had an aviary, zoo, penny arcade, and carousel. (Published by Richard Behrendt.)

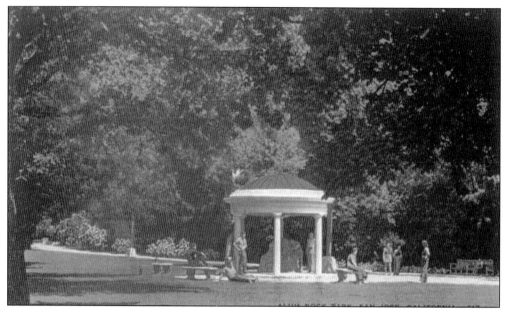

ALUM ROCK PARK, C. 1940S (LINEN POSTCARD). Founded in 1872, Alum Rock Park became California's first municipal park in the state. The park consists of 720 acres with playgrounds, picnic areas, and over 13 miles of hiking trails. It was also home to the city zoo until 1967, when the zoo was relocated to Happy Hollow at Kelley Park. (Published by D.A. Milligan News Agency.)

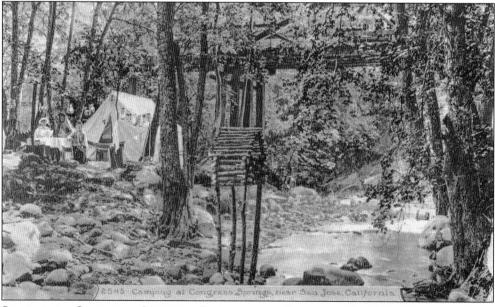

SARATOGA, CONGRESS SPRINGS, POSTMARKED JANUARY 31, 1912 (DIVIDED BACK POSTCARD). Congress Springs was discovered in the 1850s by Jud Caldwell, who called it the Pacific Congress Springs after noticing the mineral water was similar to that of Congress Springs in New York. In the mid-1860s, the Pacific Congress Springs Hotel and Resort opened for business. In 1903, the hotel was destroyed by fire and never replaced; by the 1930s, the springs closed for good. (Published by Edward H. Mitchell.)

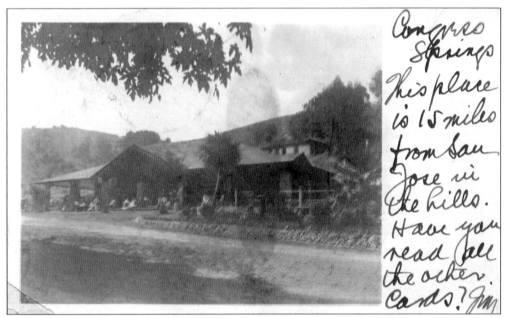

SARATOGA, CONGRESS SPRINGS, POSTMARKED JUNE 10, 1906 (REAL-PHOTO POSTCARD).
According to advertisements running in the *San Jose Mercury News* throughout the year 1900, one could ride the Saratoga Stage from San Jose to Saratoga for 50¢ or to Congress Springs for 75¢. The stage left from City Furniture in San Jose at 10:00 a.m. and 4:40 p.m. and returned at 7:00 a.m. and 7:00 p.m.

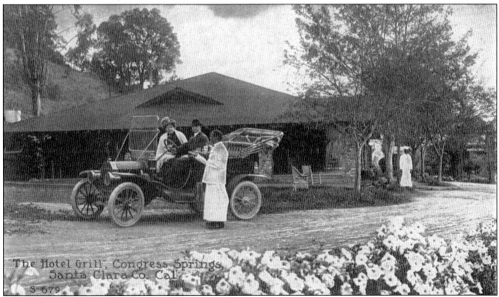

SARATOGA, HOTEL GRILL CONGRESS SPRINGS, HAND-DATED NOVEMBER 11, 1914 (SEPIA TONE REAL-PHOTO POSTCARD). An article from the May 23, 1868, *Santa Cruz Weekly Sentinel* reports on "Pacific Congress Springs on the line of the road, which is one of the prettiest country resorts to be found anywhere. We have no doubt but very soon this region will be the greatest place of resort for health-seekers and pleasure-seekers." (Published by Souvenir Publishing Co.)

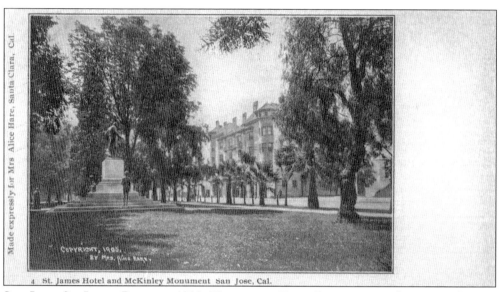

4 St. James Hotel and McKinley Monument San Jose, Cal.

SAN JOSE, ST. JAMES PARK, C. 1905 (UNDIVIDED BACK POSTCARD). This is an early view of St. James Park and the McKinley Monument. The photographer, Alice Iola Hare, moved to the city of Santa Clara from Illinois in 1895. She began a photography business, with some of her photographs appearing in *Sunset* magazine in 1902 and 1905. Her work was also shown in exhibits across the country, as well as in a self-published book titled *Vistas de San Jose and the Santa Clara Valley.* (Published by Alice Hare.)

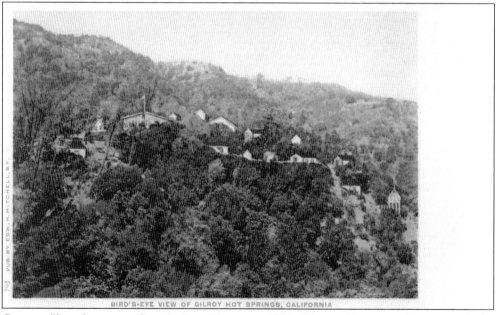

BIRD'S-EYE VIEW OF GILROY HOT SPRINGS, CALIFORNIA

GILROY HOT SPRINGS, BIRD'S-EYE VIEW, C. 1905 (HAND-COLORED POSTCARD). In 1865, Francisco Cantua was searching a ravine east of Gilroy for some of his stray flock when he discovered what would eventually become the Gilroy Hot Springs. He soon filed a claim to the property and brought his family and friends to camp at the site. In 1866, Cantua sold the land to George Roop, who immediately began developing the property. One of his first tasks was to construct a 12-mile graded road from Gilroy to the hot springs, along with some small cabins.

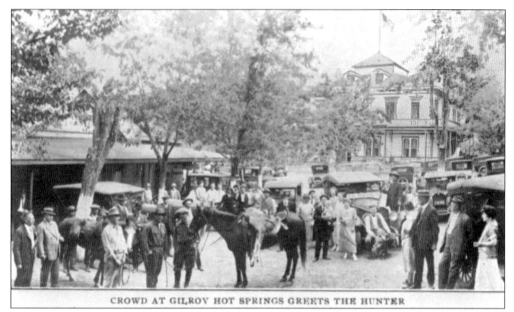

CROWD AT GILROY HOT SPRINGS GREETS THE HUNTER

GILROY HOT SPRINGS, HAND-DATED AUGUST 1930 (REAL-PHOTO POSTCARD). George Roop sold the hot springs to William and Emily McDonald in the early 1920s. Six more guest cabins were added, some of which were destroyed in a 1992 fire. The Roaring Twenties came to the hot springs with a bang. With the additional rooms, the owners were now able to handle up to 500 people a day during the peak summer season. Slot machines were soon brought in, along with bootlegged hooch, poker, and dances, which drew large crowds. (Published by Daly-Seeger Co.)

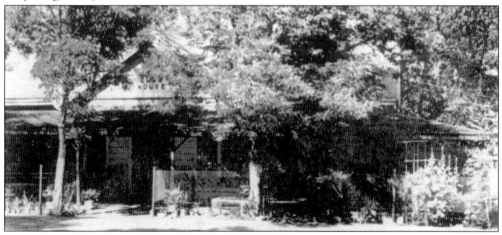

YAMATO HOT SPRINGS, CLUBHOUSE, C. 1940s (ADVERTISING POSTCARD). Prior to World War II, in 1938, Kyuzaburo Sakata purchased the springs to establish a retreat for Japanese Americans. Sakata also added "Yamato," meaning "Japanese," to the name, making it the only Japanese-owned hot springs in California. After being released from his forced internment following the war, Sakata returned to the hot springs and opened the camp to fellow internees who had no homes to return to. Unable to afford the costs to bring the facilities up to code, Sakata sold the property to Phillip S. Grimes in 1964. Grimes operated the hot springs as a private resort until 1988, when he sold it to Fukuyama International. The California Department of Parks and Recreation purchased the property in 2003 and added it to the Henry W. Coe State Park.

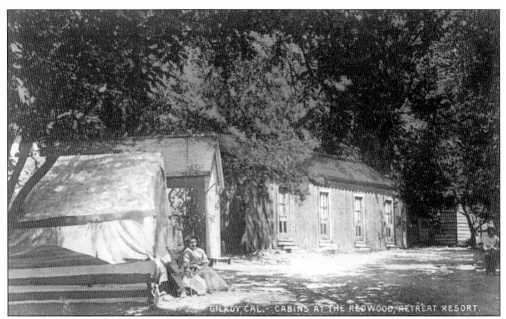

REDWOOD RETREAT, C. 1910S (HAND-PAINTED POSTCARD). In 1863, Charles and Annis Sanders homesteaded in a canyon near Gilroy, fenced off their property, and constructed a small cabin for their family. The Sanderses had originally come from Nova Scotia to California with the gold rush but eventually settled outside Gilroy and began farming. (Published by Pacific Novelty Co.)

REDWOOD RETREAT, POSTMARKED JULY 14, 1919 (REAL-PHOTO POSTCARD). In 1891, Charles Sanders began constructing a 20-room hotel, calling it Redwood Retreat. Soon, the grounds included the first outdoor swimming pool in the county, along with lawn tennis courts and bocce ball. He also planted a vineyard, orchards, and a large vegetable garden to feed his family and guests. The hotel burned to the ground on July 4, 1908, and was soon replaced with a large lodge building and 10 cabins. (Published by Janssen Lithco Co.)

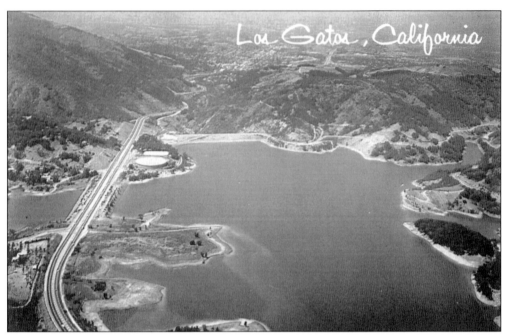

Los Gatos, California

LEXINGTON RESERVOIR, HAND-DATED JULY 1972 (REAL-PHOTO POSTCARD). Behind the third-largest dam in Santa Clara County, Lexington Reservoir covers 412 acres and is 2.5 miles long. The 195-foot-high Lexington Dam was completed in 1952 and covered the towns of Lexington and Alma and caused Highway 17 to be diverted through the area. In 1996, Lexington Dam was renamed to James J. Lenihan Dam, after the longest-serving director in the history of the Santa Clara Valley Water District. (Published by R & C Hakanson.)

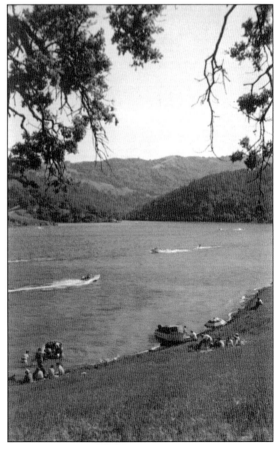

MORGAN HILL, CALERO RESERVOIR, C. 1960s (REAL-PHOTO POSTCARD). Completed in 1934, Calero Reservoir is 2.2 miles long and holds 9,934 acre-feet of water. The dam and reservoir were one of the original six reservoirs approved by voters in 1934. (Published by San Jose Chamber of Commerce.)

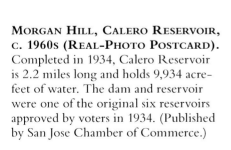

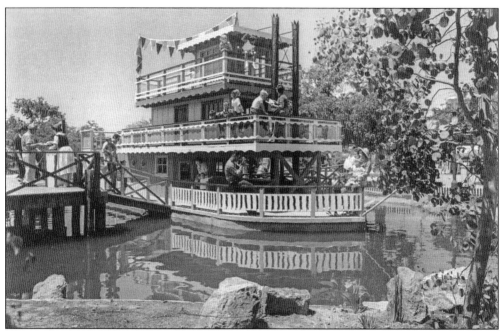

SAN JOSE, HAPPY HOLLOW, C. 1960S (REAL-PHOTO POSTCARD). Construction of Happy Hollow began in 1958, with the park opening three years later in March 1961. In 1967, the City of San Jose relocated the zoo from Alum Rock Park to an adjoining parcel next to Happy Hollow. In 1972, the two attractions were connected to one another, and the two individual entrances were consolidated into one in 1976. (Published by Yeager and Co.)

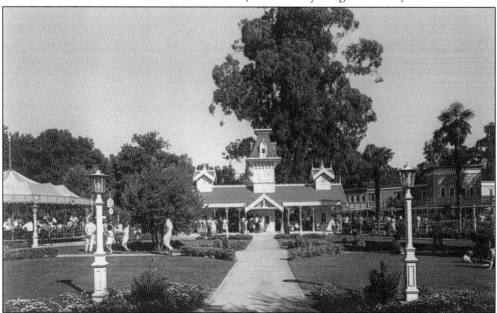

SAN JOSE, FRONTIER VILLAGE, 1970S (REAL-PHOTO POSTCARD). Located on 33 acres in South San Jose at Monterey Road and Branham Lane, Frontier Village opened on October 21, 1961. The park closed on September 28, 1980. Most of the site is now part of Edenvale Garden Park, where one can still see remnants of the old amusement park. (Published by Frontier Village.)

Santa Clara, Marriott's Great America, 1976 (Advertising Postcard). In 1972, years before Marriott's Great America opened in Santa Clara, an actor who portrayed Davy Crockett on TV and in films, Fess Parker, began his vision of a Western-themed amusement park called Frontier World. When his financing withdrew, Marriott stepped in and purchased the park before ground had been broken. On March 20, 1976, Marriott's Great America opened for business. (Published by Marriott's Great America.)

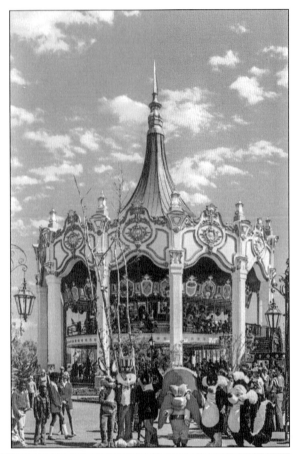

Casa De Fruta, c. 1960s (Real-Photo Postcard). Three brothers—George, Joseph, and Eugene Zanger—opened up a fruit stand along the Pacheco Pass Highway in 1943, using cherries from their uncle's orchard. Since then, the fruit stand has grown to include a gas station, camping and RV resort, restaurant, hotel, and children's playground. It has also been home to the annual Renaissance Faire for many years. (Published by Lindstrand Studios.)

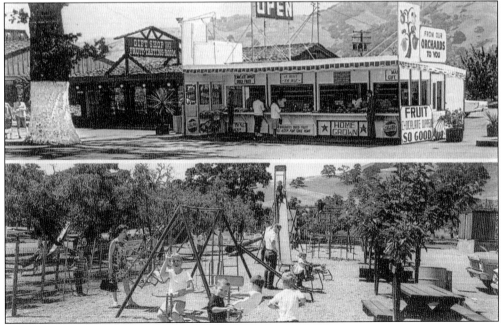

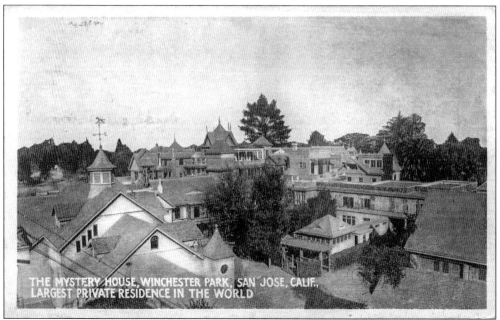

ABOVE: WINCHESTER MYSTERY HOUSE, C. 1910S (REAL-PHOTO POSTCARD); BELOW: WINCHESTER MYSTERY HOUSE, C. 1930S (REAL-PHOTO POSTCARD). With the inheritance from her husband's death in 1881, Sarah Winchester, the heiress to the Winchester Repeating Arms Company, moved to Santa Clara County in 1884 and purchased an unfinished farmhouse and began building her mansion. Believing she had to continue building a home for herself and all the lost souls of people killed by the Winchester rifles, Sarah hired carpenters who worked day and night constructing her seven-story mansion. When the 1906 earthquake struck, much of the house was destroyed, but Sarah had carpenters continue their work on the house up until her death in 1922. (Above, published by Pacific Novelty Co.)

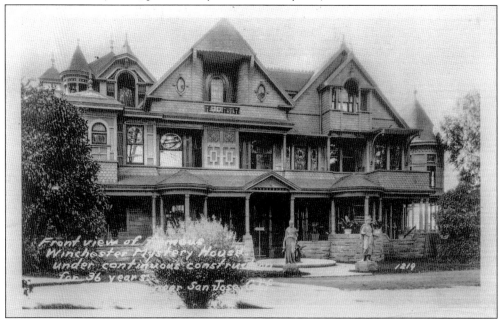

Four

GETTING THERE
ROADS AND HIGHWAYS

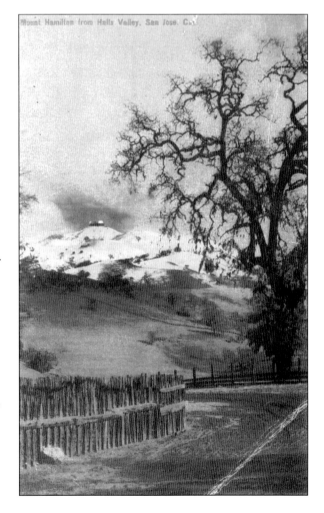

MOUNT HAMILTON, FROM HALLS VALLEY, C. 1910S (HAND-PAINTED POSTCARD). Halls Valley was one of two stage stops for changing out horse teams along the road to Mount Hamilton, the other being Smith's Creek. Halls Valley is located near the intersection of Mount Hamilton and San Felipe Roads. Joseph D. Grant began acquiring property in Halls Valley as early as the 1880s to build his vast cattle ranch. In 1975, Santa Clara County purchased the property and opened the 9,560–acre Joseph D. Grant County Park in 1978. (Published by Pacific Novelty Co.)

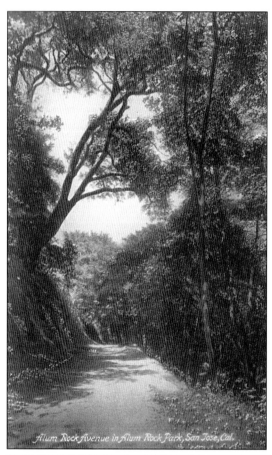

ALUM ROCK PARK, ALUM ROCK AVENUE, C. 1910 (HAND-COLORED POSTCARD). Due to landslides in the late 1990s, the City of San Jose closed Alum Rock Avenue to vehicle traffic into the park. The road is still used as a walking path and bike trail. The only avenue now available into the park is Penitencia Creek Road. (Published by M. Rieder, Publ.)

Alum Rock Avenue in Alum Rock Park, San Jose, Cal.

MOUNT HAMILTON, ROAD TO LICK OBSERVATORY, POSTMARKED NOVEMBER 3, 1910 (DIVIDED BACK POSTCARD). Constructed in the 1870s to allow access to the Lick Observatory, the 19-mile road is said to have 365 curves, one for each day of the year. The road was originally designed for horses and wagons to haul cargo and building materials to the new observatory. (Published by Cardinell-Vincent Co.)

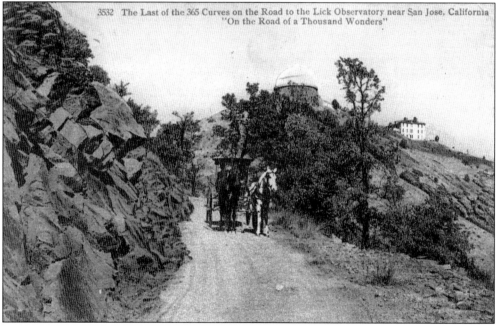

3532 The Last of the 365 Curves on the Road to the Lick Observatory near San Jose, California "On the Road of a Thousand Wonders"

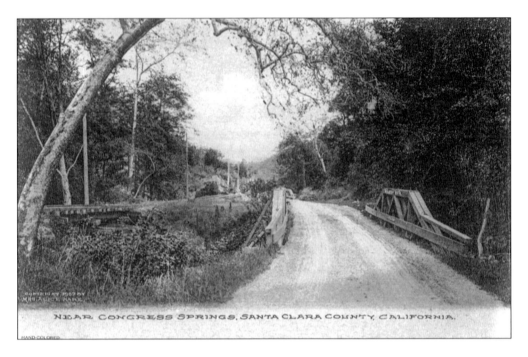

ABOVE: SARATOGA, CONGRESS SPRINGS, POSTMARKED AUGUST 19, 1908 (HAND-COLORED POSTCARD); BELOW: SARATOGA, CONGRESS SPRINGS, C. 1910S (DIVIDED BACK POSTCARD). Constructed between 1865 and 1871 by a private group of investors to reach the vast redwood forests, Congress Springs Road was named after the famous Congress Springs in Saratoga, New York. Portions of the original road are now known as Highway 9. (Above, published by Alice Hare; below, published by Newman Post Card Co.)

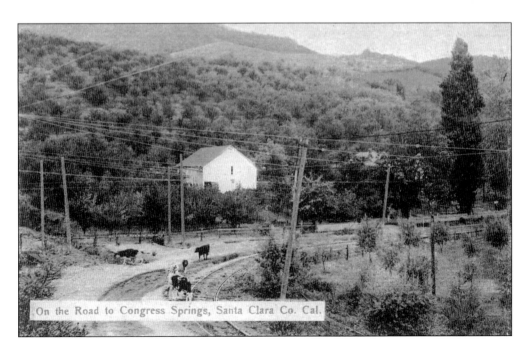

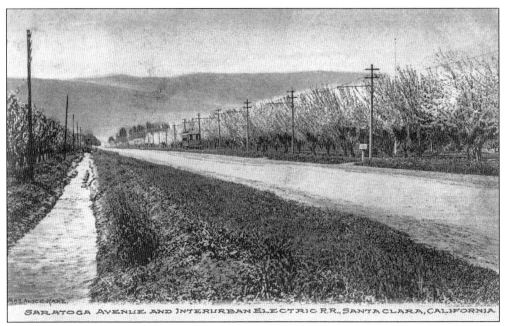

SARATOGA AVENUE AND INTERURBAN ELECTRIC R.R., SANTA CLARA, CALIFORNIA.

984 Brokaw Road, Santa Clara, Cal.

SARATOGA, SARATOGA AVENUE, POSTMARKED JUNE 19, 1908 (HAND-COLORED POSTCARD). Running along Saratoga Avenue, the Interurban Electric Railroad ran from downtown San Jose and west along Stevens Creek Boulevard, where it turned onto Saratoga Avenue at Meridian Corners. From there, it proceeded on to Congress Junction and into Saratoga and Congress Springs. From the Saratoga Station, passengers were able to catch the trolleys directly to Los Gatos to the south or Cupertino and Palo Alto to the north. (Published by the Albertype Co.)

SANTA CLARA, BROKAW ROAD, C. 1910S (DIVIDED BACK POSTCARD). Although postmarked October 19, 1950, this card was manufactured around 1910. Brokaw Road appears in an early 1866 map of Santa Clara where, as it crosses the Southern Pacific Railroad tracks and Sherman Street, the name changes to Benton Street. Most of Brokaw Road was removed to make way for the San José Airport. (Published by Souvenir Publishing Co.)

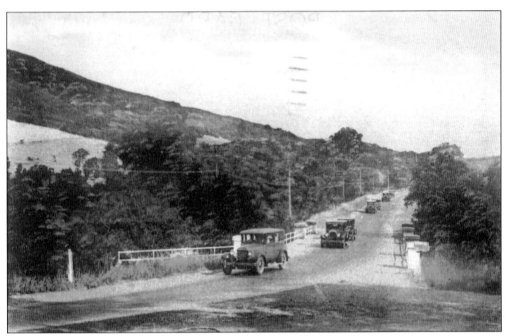

ABOVE: ALMA, SANTA CRUZ HIGHWAY, POSTMARKED MAY 29, 1936, (REAL-PHOTO POSTCARD); BELOW: LOS GATOS–SANTA CRUZ HIGHWAY, c. 1940 (REAL-PHOTO POSTCARD). Highway 5 (now called the Old Santa Cruz Highway) between Los Gatos and Santa Cruz opened to vehicle traffic in 1910 as a graded dirt road. By 1921, the highway was paved with eight inches of cement and widened to 16 feet to accommodate military vehicles between Camp Gigling (the current Fort Ord) and the Bay Area. (Above, courtesy William A. Wulf.)

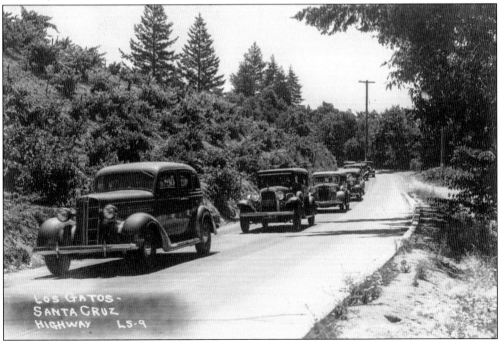

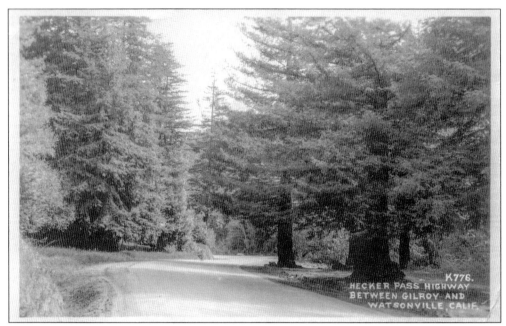

GILROY, HECKER PASS HIGHWAY, POSTMARKED JUNE 25, 1932 (REAL-PHOTO POSTCARD).
Named after Santa Clara County supervisor Henry Hecker, Hecker Pass Highway opened as part of the "Yosemite to the Sea Highway" on May 27, 1928. The western portion of State Route 152 traverses the Santa Cruz Mountains from Gilroy on the eastern side in Santa Clara County to Watsonville on the western side in Santa Cruz County.

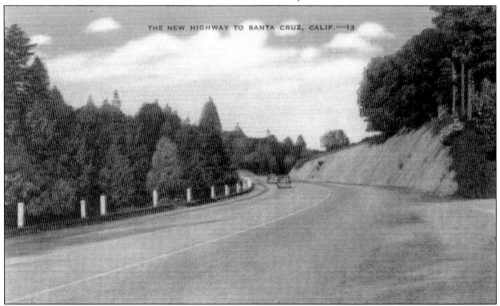

LOS GATOS, THE NEW HIGHWAY, POSTMARKED JUNE 23, 1947 (LINEN POSTCARD).
Opening in 1940, State Route 17 replaced the old Highway 5, now known as the Old Santa Cruz Highway. With the construction of Lexington Reservoir in the early 1950s, Highway 17 had to be rerouted to higher ground around the lake. During periods when the lake is low, portions of the old highway are plainly visible. (Published by F.R. Fulmer.)

Five

HITTING THE RAILS
RAILROADING THROUGHOUT
THE COUNTY

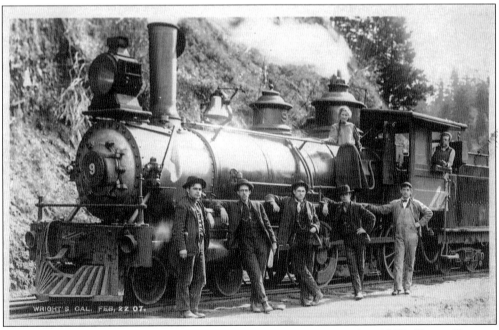

WRIGHTS, LOCOMOTIVE NO. 9, POSTMARKED DECEMBER 17, 1907 (REAL-PHOTO POSTCARD). South Pacific Coast Railroad Locomotive No. 9 sits on the tracks in Wrights as the rebuilding of the town and tunnel continue after the 1906 earthquake. This narrow-gauge engine was built by the Baldwin Locomotive Works in Philadelphia in 1880. Seen on the locomotive's running board is Alice Matty, who grew up in Wrights and became the first female telegrapher and station agent for Southern Pacific in California. (Courtesy William A. Wulf.)

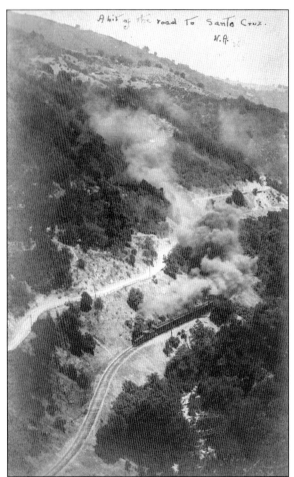

A bit of the road To Santa Cruz. N.A.

LEFT: LOS GATOS, ENTERING SANTA CRUZ MTS., POSTMARKED MARCH 16, 1907 (REAL-PHOTO POSTCARD); BELOW: LOS GATOS, ENTERING SANTA CRUZ MTS., POSTMARKED AUGUST 14, 1939 (REAL-PHOTO POSTCARD). When the narrow-gauge South Pacific Coast Railroad began service in 1878 between Los Gatos and Santa Cruz along Los Gatos Creek, there were nine tunnels and eight trestles crossings over rivers and creeks. The first tunnel, or Tunnel No. 1, was just out of town, south of Toll House, and collapsed in 1877 before the line was officially opened. The second tunnel, Tunnel No. 2, was 190 feet long in Wildcat Canyon north of Alma. In 1902, as the railroad upgraded its tracks to standard gauge, tracks were rerouted around tunnel No. 2. The tunnel collapsed in 1903 and is now buried under the James J. Lenihan Dam. Tunnel No. 3, in Wright Station, was 6,115 feet long and is the only existing tunnel along the old rail bed in Santa Clara County. The remaining tunnels were in Santa Cruz County. (Both, courtesy William A. Wulf.)

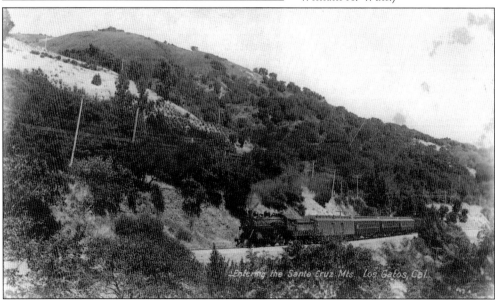

Entering the Santa Cruz Mts. Los Gatos, Cal.

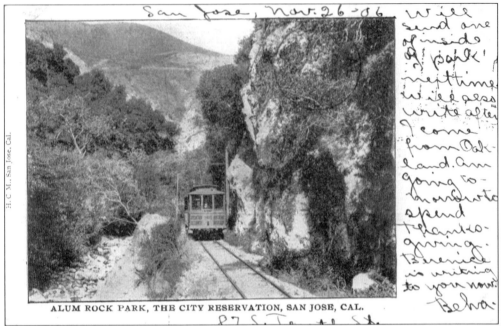

ALUM ROCK PARK, THE CITY RESERVATION, SAN JOSE, CAL.

SAN JOSE, ALUM ROCK PARK, POSTMARKED NOVEMBER 27, 1906 (UNDIVIDED BACK POSTCARD). Train service first started to Alum Rock Park in 1896 with a steam train operated by the Peninsular Railway. A familiar-appearing open streetcar was pulled by a steam dummy locomotive. That was replaced by an electrified narrow-gauge streetcar in 1902. The Santa Clara Line went from downtown San Jose, along Santa Clara Avenue to Alum Rock Avenue, to Kirk Avenue and Toyon Avenue, turning east on Penitencia Creek Road, and ending in Alum Rock Park. As vehicle traffic became more present in the park, it spelled the end of the trolley. The Alum Rock line was shut down by 1931. (Published by H.C.M.)

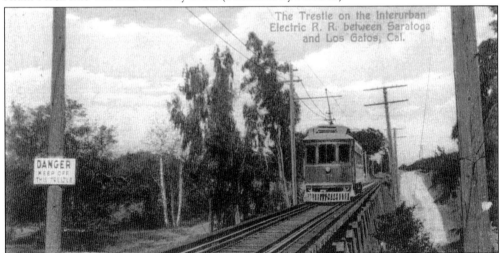

LOS GATOS, INTERURBAN ELECTRIC R.R., POSTMARKED NOVEMBER 8, 1909 (DIVIDED BACK POSTCARD). Years before the average person could afford an automobile, the Peninsula Interurban crisscrossed the county, making travel convenient and inexpensive. The electrified trolleys stretched from Palo Alto in the north, to Saratoga and Los Gatos in the south, and east to San Jose and Alum Rock Park. (Published by Geo. P. Rasmussen.)

97

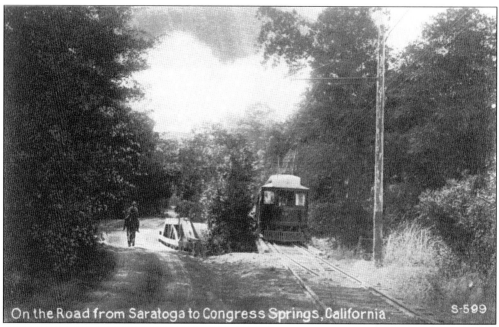

On the Road from Saratoga to Congress Springs, California S-599

SARATOGA ROAD TO CONGRESS SPRINGS, HAND-DATED NOVEMBER 11, 1914 (SEPIA TONE REAL-PHOTO POSTCARD). By 1921, there were three scheduled westbound runs between Saratoga and Congress Springs: 11:15 a.m., 5:15 p.m., and 7:05 p.m.; and two eastbound cars: 11:00 a.m. and 7:14 p.m. One of the first Interurban Railroad connections to be discontinued in February 1933 was the Congress Junction lines. Within a year, most of the rail lines were discontinued, and in June 1935, the railway was legally disincorporated. (Published by Souvenir Publishing Co.)

Palo Alto Tree - Palo Alto, Cal. S-475

PALO ALTO, RAILROAD AND TREE, C. 1910 (REAL-PHOTO POSTCARD). A steam engine crosses the Southern Pacific bridge over the San Francisquito Creek as it approaches Palo Alto from the south. The tree known as "Palo Alto," Spanish for "tall tree," is credited with being the source of the city's name.

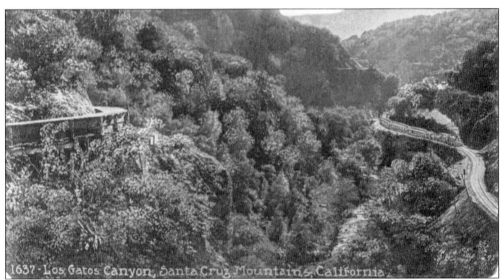

LOS GATOS CANYON, C. 1915 (DIVIDED BACK POSTCARD). As the roads over the Santa Cruz Mountains were improved, making traveling "over the hill" easier and less expensive than trains, the last South Pacific Coast Railroad crossed over the mountains on March 4, 1940, when the railroad ceased operations. The water flume to the left in the photograph was built by the San Jose Water Company in 1871. It ran more than three miles long, beginning at the Jones Dam on Los Gatos Creek above Alma. (Published by Souvenir Publishing Co.)

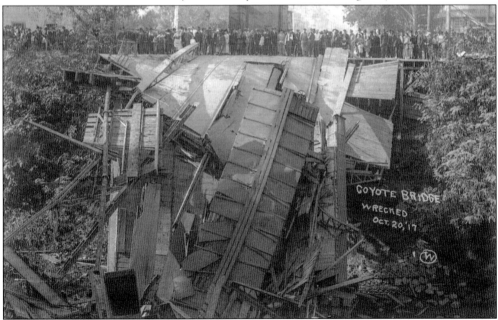

SAN JOSE, COYOTE BRIDGE, DATED OCTOBER 20, 1917 (REAL-PHOTO POSTCARD). On October 20, 1917 at 5:17 p.m., a train pushing three boxcars carrying beets and dried prunes was crossing the Seventeenth Street bridge over Coyote Creek when, all of a sudden, the bridge collapsed under the enormous weight of the boxcars. Sadly, 12-year-old Lawrence Foster was walking across the bridge at the time and later died from his injuries. (Courtesy the California History Room, California State Library, Sacramento, California.)

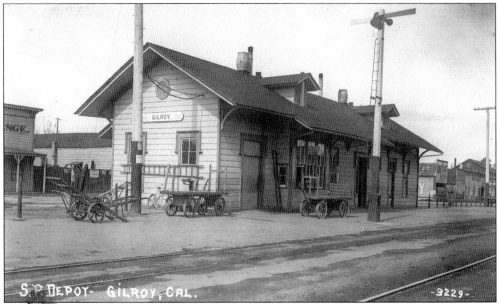

GILROY, S.P. DEPOT, C. 1910 (REAL-PHOTO POSTCARD). The original depot for Gilroy (seen here) was constructed in 1869 so that local farmers were able to ship their produce. As the town grew, the need for a larger and more modern depot became necessary. The new Italian Renaissance-style depot was moved 500 feet south and opened in 1918. (Published by Edward H. Mitchell, courtesy the California History Room, California State Library, Sacramento, California.)

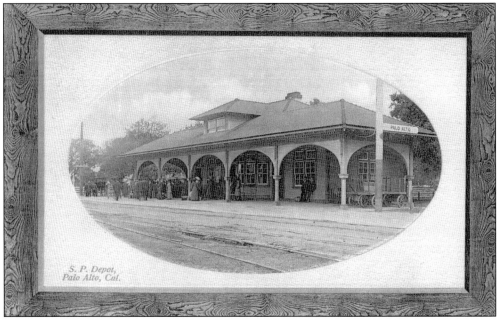

PALO ALTO, SOUTHERN PACIFIC DEPOT, POSTMARKED OCTOBER 10, 1914 (REAL-PHOTO POSTCARD). The original Southern Pacific Railway depot from the late 1880s was a small open-sided structure that used a boxcar for the ticket and shipping office. In 1893, the sides were enclosed, and in 1896, it was replaced with the station seen here. (Published by Pacific Novelty Co.)

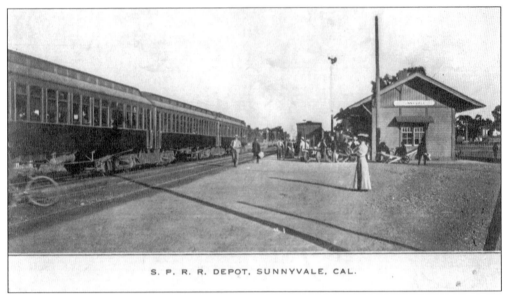

S. P. R. R. DEPOT, SUNNYVALE, CAL.

SUNNYVALE, SOUTHERN PACIFIC DEPOT, POSTMARKED AUGUST 16, 1911 (REAL-PHOTO POSTCARD). The first Sunnyvale depot was moved from Goleta, California, in 1901 in two 10-foot sections. Once in place, there were two waiting rooms, one for men and one for women, with both having the luxury of a potbelly stove for heat. The station continued to serve Sunnyvale until 1951, when a freak tornado hit Sunnyvale, including the depot, ripping off its roof. Southern Pacific disassembled what was left of the building and relocated it elsewhere. (Published by Polychrome Co.)

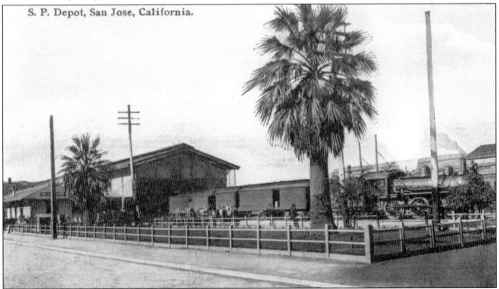

S. P. Depot, San Jose, California.

SAN JOSE, SOUTHERN PACIFIC DEPOT, C. 1910S (DIVIDED BACK POSTCARD). The first train to pull in to the new San Francisco & San Jose Railroad (SF&SJRR) Station on Market and Bassett Streets in downtown San Jose was on January 16, 1864. In 1867, the Southern Pacific Railroad purchased the SF&SJRR. The Cahill Station opened in December 1935 and was renamed Diridon Station in 1994 after former Santa Clara County supervisor Rod Diridon. (Published by Pacific Novelty Co.)

101

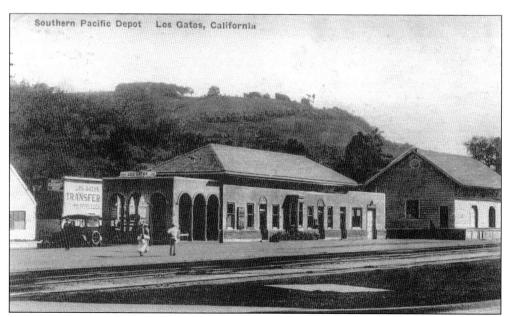

LOS GATOS, SOUTHERN PACIFIC DEPOT, POSTMARKED JANUARY 26, 1936 (HAND-COLORED POSTCARD). The fourth and final train depot in Los Gatos was demolished in 1964, five years after the final passenger train pulled away in 1959. The site of the station is now the Los Gatos Town Plaza Park on the corner of Main Street and Santa Cruz Avenue. (Published by the Albertype Co.)

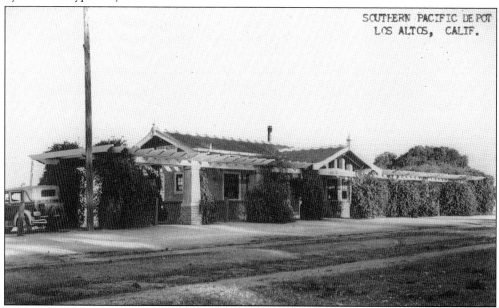

LOS ALTOS, SOUTHERN PACIFIC DEPOT, DATED FEBRUARY 4, 1940 (REAL-PHOTO POSTCARD). Steam train service in Los Altos began in 1908, with trolleys following in 1910. The depot provided both passenger and freight service until the late 1950s. In 1958, Southern Pacific stopped service along the line altogether and removed the tracks. In the early 1960s, the Foothill Expressway was constructed along the old rail right-of-way. (Courtesy Sourisseau Academy for State and Local History, San José State University.)

Six

AGRICULTURE
WHERE IT ALL BEGAN

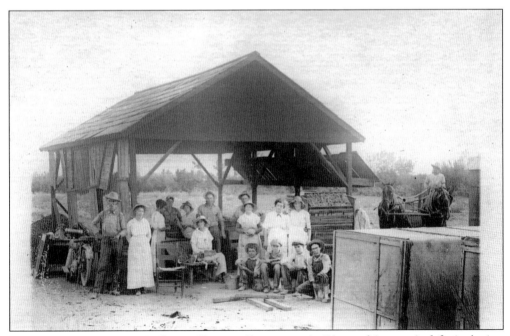

FRUIT DRYING, C. 1911 (REAL-PHOTO POSTCARD). Pictured is a typical fruit-drying operation with a shed to protect the workers and with pallets of cut fruit ready for drying. Also notice the two horses pulling a wagon used to haul the fruit from the orchard to the shed. An early-style motorcycle is located next to the shed.

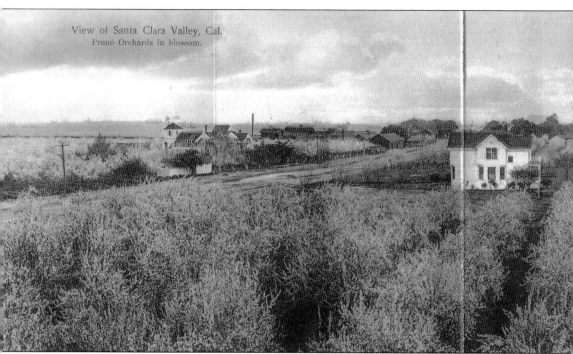

VIEW OF SANTA CLARA VALLEY, HAND-DATED NOVEMBER 18, 1909 (PANORAMIC HAND-COLORED POSTCARD). This five-panel panoramic 17.75-by-5.5-inch postcard depicted a typical

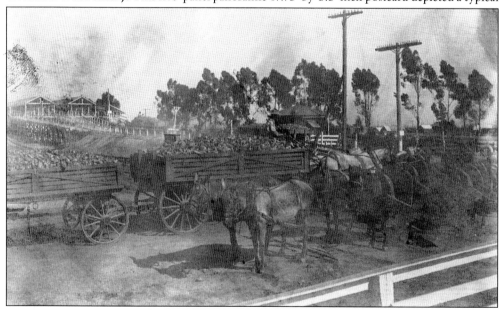

BEET PROCESSING, POSTMARKED SEPTEMBER 3, 1908 (DIVIDED BACK POSTCARD). In 1902, the US Government named Santa Clara County the third highest county in California in beet production out of the 17 beet-producing counties. Handwritten on the back of the card was, "This card shows the delivery of beets at the factory—and the incline to the sheds where the beets are stored. The picture of the factory includes the other end of the beet sheds from whence the beets are conveyed into the factory—by means of a flume."

turn-of-the-century orchard scene in Santa Clara County. (Published by F.A. Alderman.)

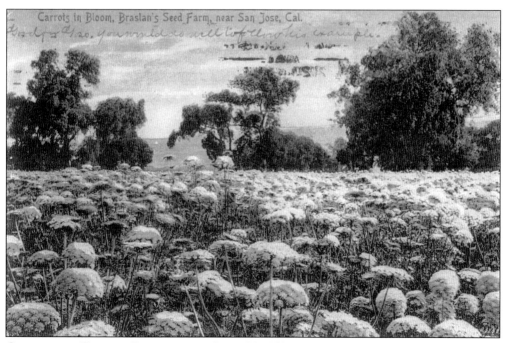

CARROTS IN BLOOM, POSTMARKED JUNE 20, 1907 (HAND-COLORED POSTCARD). The Braslan's Seed Farm started business in 1905 by C.P. Braslan and consisted of 400 acres in Edenvale and Gilroy. The main warehouse was located at Coyote Station, where seeds were shipped to the East Coast, Europe, and Asia. (Published by M. Rieder, Publ.)

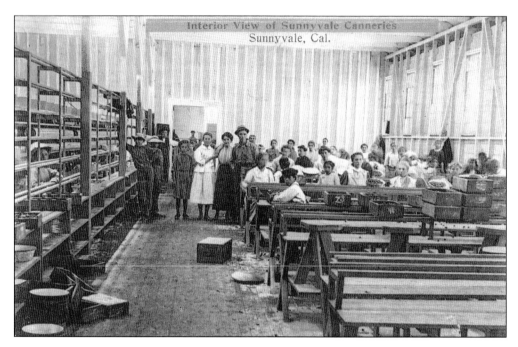

ABOVE: INSIDE SUNNYVALE CANNERY, SUNNYVALE, C. 1912 (HAND-COLORED POSTCARD); BELOW: SUNNYVALE CANNERY, C. 1912 (HAND-COLORED POSTCARD). Located on South Fair Oaks Avenue, George H. Hooke opened the Sunnyvale Cannery in 1907. The cannery primarily produced maraschino cherries until 1921, when they added peaches to their production. Hooke declared bankruptcy and sold to Schuckle and Company in 1925. The cannery finally closed in 1962 and sold to the California Canners and Growers Company in 1963. (Both, published by C.W. Stubbs.)

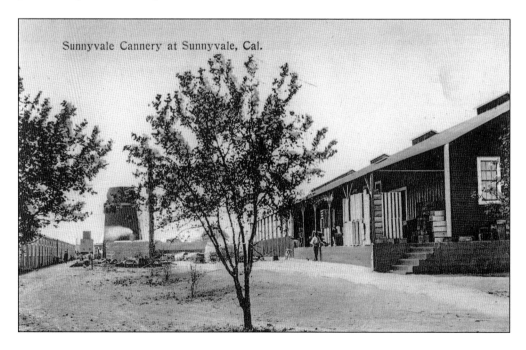

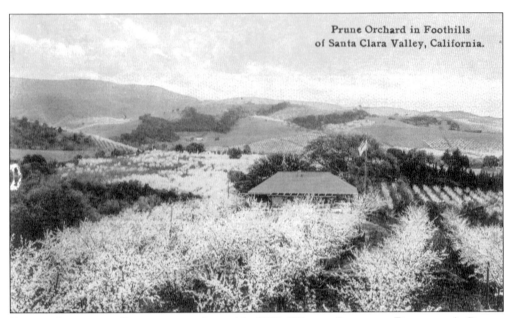

PRUNE ORCHARD, POSTMARKED JULY 16, 1913 (HAND-COLORED POSTCARD). Prunes were first introduced to Santa Clara County by Louis Pellier in 1856. By 1919, more prune trees (7,652,000) were planted in Santa Clara County than the rest of the states combined. In the early 1960s, the county saw a decline in all aspects of agriculture due to the building of new homes and businesses on its prime farm real estate. There are no longer any commercial prune orchards left in Santa Clara County. (Published by Pacific Novelty Co.)

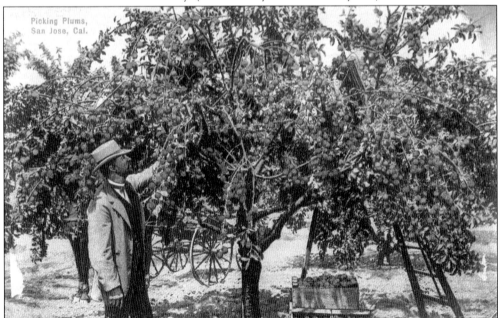

PICKING PLUMS, C. 1910S (DIVIDED BACK POSTCARD). On the back of a St. James Park postcard dated October 21, 1917, a cannery worker named Bernice writes, "I am laboring fruit cans now. Done 618 boxes (6-gal. cans, 3708 cans one day, 8 hrs.) for $4.50, but can't do it every day." (Published by M. Rieder, Publ.)

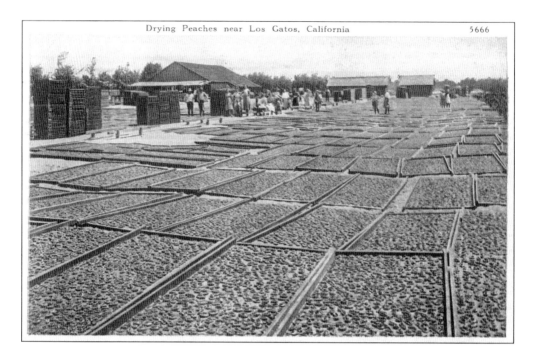

ABOVE: DRYING PEACHES, POSTMARKED JULY 23, 1929 (HAND-COLORED POSTCARD); BELOW: FRUIT DRYING, C. 1940 (REAL-PHOTO POSTCARD). Once a common sight in Santa Clara County, thousands of trays of drying peaches and apricots were spread throughout the county. Loss of land to development and then to foreign producers, such as Turkey, South Africa, Argentina, and Chile, have all contributed to the decline of fruit production. (Above, published by Pacific Novelty Co.; below, published by Wayne Paper Box & RPTG. Corp.)

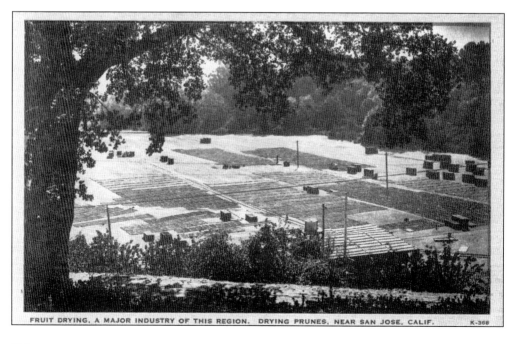

FRUIT DRYING, A MAJOR INDUSTRY OF THIS REGION. DRYING PRUNES, NEAR SAN JOSE, CALIF. K-368

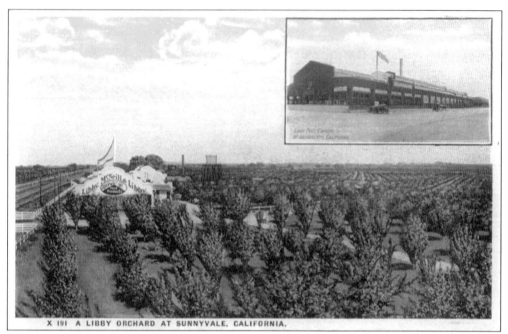

X 191 A LIBBY ORCHARD AT SUNNYVALE, CALIFORNIA.

SUNNYVALE, LIBBY ORCHARD, C. 1920S (DIVIDED BACK POSTCARD). In 1907, Libby opened the Sunnyvale cannery with a majority of workers being women. Depending on the piece rate, workers could make between $1.50 and $3.75 a day. The plant was located on Mathilda and Evelyn Avenues and closed in 1981. The old water tank still stands today as a tribute to Sunnyvale's roots. (Published by Commercialchrome.)

PLANT ENTRANCE & GENERAL OFFICES, SCHUCKL & CO. Inc., SUNNYVALE, CALIFORNIA 706

SUNNYVALE, SCHUCKLE & CO., C. 1940S (REAL-PHOTO POSTCARD). Max Schuckle started his cannery business in Niles, California, in 1917, moving to Sunnyvale in 1925 when he purchased the Sunnyvale Canneries. The business was located near Fair Oaks and East Evelyn Avenues and operated until 1962, when the cannery was sold to California Canners and Growers. (Published by Mastercraft Pictures.)

OSTRICH FARM, HAND-DATED MARCH 27, 1909 (DIVIDED BACK POSTCARD). Opening in February 1904 on the corner of Alum Rock and King Roads in San Jose, the San Jose Ostrich Company began raising ostriches for their plumes and eggs. It later moved to a larger location on Alum Rock Road near Capitol Avenue, and in 1909, it relocated to Sacramento. (Published by Newman Post Card Co.)

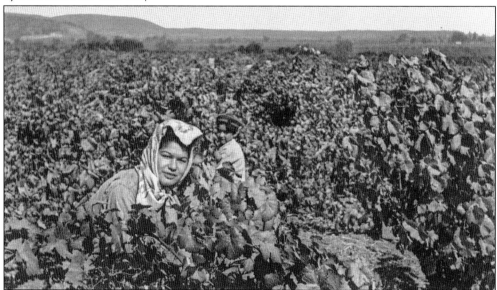

SAN MARTIN, SAN MARTIN WINERY, C. 1960S (REAL-PHOTO POSTCARD). By the 1850s, Santa Clara County had more vineyards than any other county in the state. By 1883, there were more than 100 wineries with almost 15,000 acres of grapes growing in the county. At the turn of the century, the deadly phylloxera killed off over 10,000 acres of vines, driving more than half of the wineries out of business. As of 2015, Santa Clara County is home to 53 wineries with a combined 1,580 acres of vineyards. (Published by Forest of Pasadena.)

Seven

EARTHQUAKE OF 1906
THE 5:12 A.M. AWAKENING

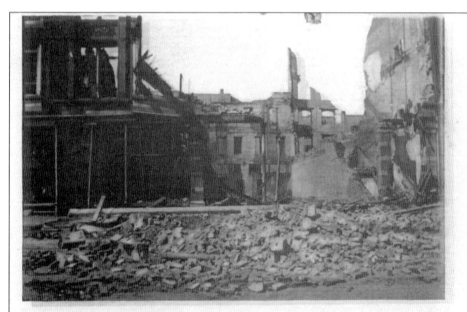

Second St., and San Fernando St., San Jose, Cal., after the Earthquake,
April 18, 1906.
Published by the Rieder-Cardinell Co., Los Angeles and Oakland. No. 234.

SAN JOSE, SECOND AND SAN FERNANDO STREETS, C. 1906 (UNDIVIDED BACK POSTCARD).
Most of the buildings around Second and San Fernando Streets were a complete loss due to the
quake. One of the most devastating losses was the Dougherty Building, which housed Andrew
P. Hill's collection of 24,000 glass negatives. (Published by M. Rieder, Publ.)

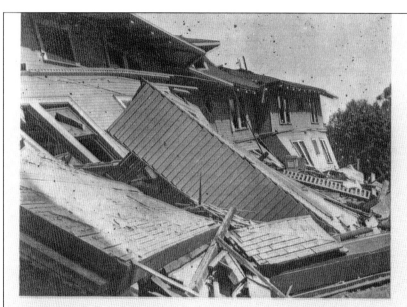

Vendome Hotel Annex, San Jose, Cal., after the Earthquake, April 18, 1906.
Published by the Rieder-Cardinell Co., Los Angeles and Oakland. No. 230.

SAN JOSE, VENDOME HOTEL ANNEX, C. 1906 (UNDIVIDED BACK POSTCARD). In 1903, just three years before the earthquake, the Vendome built a three-story annex northwest of the main hotel. When the earthquake hit, fourteen people were staying in the annex, with one person dying from his injuries. (Published by M. Rieder, Publ.)

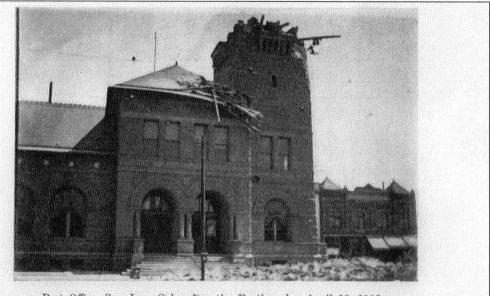

Post Office, San Jose, Cal., after the Earthquake, April 18, 1906.
Published by the Rieder-Cardinell Co., Los Angeles and Oakland. No. 231.

SAN JOSE, POST OFFICE, C. 1906 (UNDIVIDED BACK POSTCARD). Designed by Willoughby J. Edbrooke and built in 1892, it served as San Jose's post office until the 1930s. From 1937 until 1969, the building served as the city's library, and in 1972, it was converted to the Fine Arts Gallery. (Published by M. Rieder, Publ.)

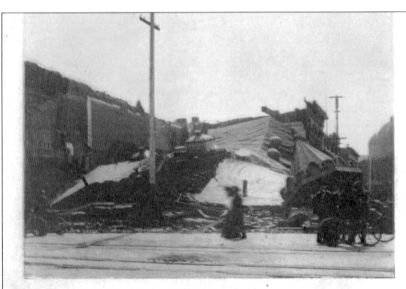

Elks' Hall, West Santa Clara St., San Jose, Cal., after the Earthquake,
April 18, 1906.
Published by the Rieder-Cardinell Co., Los Angeles and Oakland. No. 229.

SAN JOSE, ELKS HALL, C. 1906 (UNDIVIDED BACK POSTCARD). Constructed in 1875 at 58 West Santa Clara Street at the corner of Lightston Alley, the Elks Hall was a complete loss. The Elks Club had only moved into the building in 1902, but after the earthquake they decided to rebuild on North Second Street. (Published by M. Rieder, Publ.)

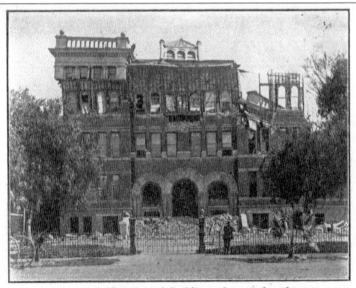

San Jose High School Building, after earthquake.

SAN JOSE, SAN JOSE HIGH SCHOOL, C. 1906 (UNDIVIDED BACK POSTCARD). Constructed in 1898 on San Fernando Street between Sixth and Seventh Streets, the school was a complete loss when the building collapsed. The school was rebuilt in a Spanish Colonial style and reopened in 1908. In 1952, the high school moved to its current site at 275 North Twenty-Fourth Street. As the second oldest high school in California, San Jose High School celebrated its 150th anniversary in 2013. (Published by M. Rieder, Publ.)

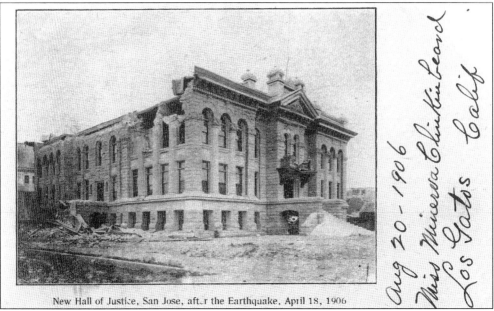

New Hall of Justice, San Jose, after the Earthquake, April 18, 1906

Aug 20 - 1906 Miss Minerva Chinkinheard Los Gatos Calif

SAN JOSE, NEW HALL OF JUSTICE, C. 1906 (UNDIVIDED BACK POSTCARD). The Hall of Justice stood on the corner of Market and St. James Streets until 1962, when it was torn down to be replaced by the Santa Clara County Superior Court Building. In 1906, the Hall of Justice had yet to be opened and was awaiting to be dedicated when the quake hit. Two years later, in 1908, after extensive reconstruction, the building finally opened.

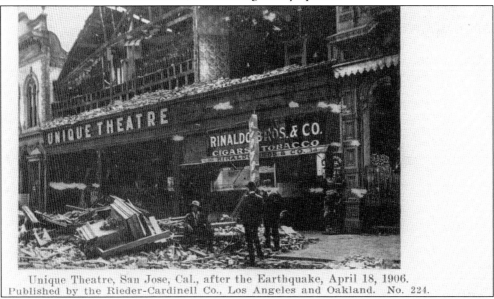

Unique Theatre, San Jose, Cal., after the Earthquake, April 18, 1906.
Published by the Rieder-Cardinell Co., Los Angeles and Oakland. No. 224.

SAN JOSE, UNIQUE THEATRE, C. 1906 (UNDIVIDED BACK POSTCARD). Opening in 1903, the Unique Theater, located at 20 East Santa Clara Street, presented movies and vaudeville acts until the earthquake in 1906. Unable to reopen due to the extensive damage, the owner Sid Grauman moved to Los Angeles and opened Grauman's Chinese Theatre in Hollywood. Roscoe "Fatty" Arbuckle was said to have gotten his start in show business at the Unique. (Published by M. Rieder, Publ.)

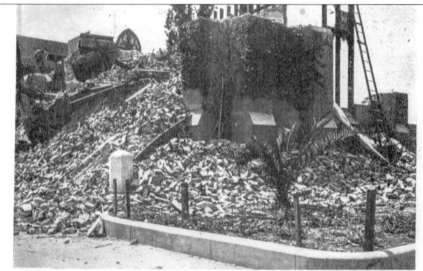

St. Patrick's Church, Santa Clara St., San Jose, Cal., after the Earthquake, April 18, 1906.

Published by the Rieder-Cardinell Co. Los Angeles and Oakland No. 222

SAN JOSE, ST. PATRICK'S CHURCH, C. 1906 (UNDIVIDED BACK POSTCARD). Completed in 1888 on the corner of Santa Clara and Ninth Streets, St. Patrick's was a complete loss from the earthquake. St Patrick's was rebuilt next door using rubble from the original church for a new foundation. In the 1960s, a more modern church was constructed and dedicated on St. Patrick's Day in 1967. (Published by M. Rieder, Publ.)

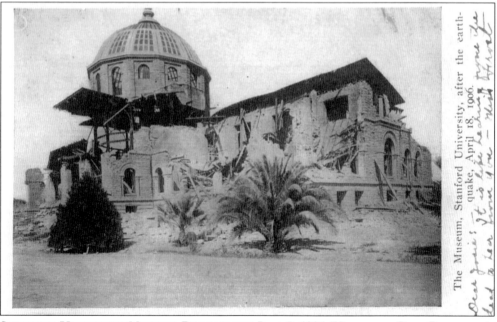

STANFORD UNIVERSITY MUSEUM, POSTMARKED JUNE 5, 1906 (UNDIVIDED BACK POSTCARD). The main portion, built in a Neoclassical style, opened in 1894 and suffered little damage from the earthquake. The heavily damaged portion was an expansion that opened in 1905 and housed collections of pottery, Salviati Glass, marble sculptures and antiquities, with most being destroyed. (Published by M. Rieder, Publ.)

115

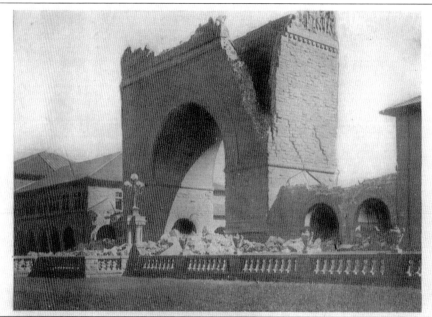

STANFORD UNIVERSITY MEMORIAL ARCH, C. 1906 (UNDIVIDED BACK POSTCARD). Completed in 1902, the original Memorial Arch dedicated to Leland Stanford Jr. framed the entrance to the Main Quad. At the time it was originally constructed, it was a hollow structure with stairs leading to an observation deck on the top. Due to the overwhelming cost to rebuild, the university decided not to rebuild but instead cap the bases with red tile roofs, which can still be seen today. (Published by M. Rieder, Publ.)

STANFORD UNIVERSITY MEMORIAL CHURCH ENTRANCE, C. 1906 (BOTH, UNDIVIDED BACK POSTCARDS). It was meant to be the centerpiece of the Stanford campus. Leland Stanford's wife, Jane, had the church constructed in the Inner Quadrangle in honor of her late husband. Constructed between 1899 and 1903, the church was heavily damaged in the 1906 earthquake. It was not until two years later in 1908 that reconstruction finally began. It would take another five years for the restoration to be complete, except for the church's bell tower, which was never restored. (Published by M. Rieder, Publ.)

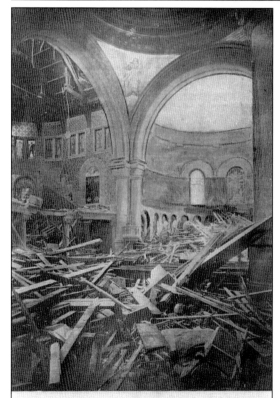

Facing the Altar, Memorial Church, Stanford University, Cal., after earthquake and fire, April 18, 1906.

Eight

Other Cards from Santa Clara County
From Auto Racing to True Crime

$5.00 REWARD! STOLEN!

One Gent's Light Roadster Clipper Bicycle, Model '98, No. 26,840, black enamel, with mahogany rims, M. & W. tires, small piece out of right handle. Arrest and wire.

San Jose, Jan. 12, 1900.

R. J. LANGFORD,
Sheriff Santa Clara Co.

SHERIFF'S POSTCARD, DATED JANUARY 12, 1900 (REWARD POSTCARD). Wanted postcards were used in the late 1800s and early 1900s to get the word to other law enforcement officers to look out for people who were wanted for minor offenses or for stolen property. Looking for a stolen bicycle, Sheriff R.J. Langford mailed this card to Constable White in Gilroy in January 1900.

$15.00 REWARD.

Stolen from Wrights Station, December 9, 1899, one small bay horse, white star in forehead, 800 or 900 lbs. roached mane, spring wagon, yellow body, black gear, one seat, room for two, breeching nailed to shaft, tracked toward Santa Cruz.

Supposed thief, Ah Yen, Chinaman, aged 39 years, height 5 feet, 6¾ inches, weight 120 lbs., No. 6 shoe, blind in one eye.

Arrest and wire.

R. J. LANGFORD,

Dec. 13, 1899. Sheriff Santa Clara County, Cal.

SHERIFF'S POSTCARD, DATED DECEMBER 13, 1899 (REWARD POSTCARD). This particular card was mailed to Constable White in Gilroy. Sheriff Robert J. Langford was searching for a stolen horse from Wrights Station. The suspected thief, Ah Yen, was a well-known criminal throughout Santa Clara County. His rap sheet included kidnapping of a child, illegal gambling, assault, and arson.

Card No. 141. SAN JOSE, CAL., March 7, 1907.

Wanted for Passing Bogus Check.

Henry or Harry Bailey, true name Bailey Harrison.

Age, 45 years; weight, 150 lbs.; height, 5 ft. 7 or 8 inches; smooth shaven; dark complexion. When last seen was wearing gray suit and dark Fedora hat. Very neat appearance, expert accountant, and good penman; quite a talker. Wrinkled on neck. Follows the races.

Arrest if found, and wire me at my expense

ARTHUR B. LANGFORD,

Sheriff of Santa Clara County.

SHERIFF'S POSTCARD, DATED MARCH 7, 1907 (WANTED POSTCARD). Mailed to the constable in Downieville, California, in March 1907, this card explains that Sheriff Arthur Langford was searching for Bailey Harrison for passing a bogus $20 check in Palo Alto.

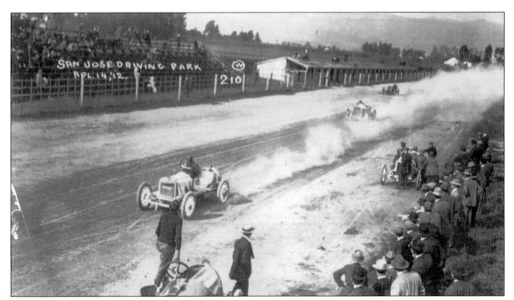

SAN JOSE DRIVING PARK, DATED APRIL 14, 1912 (REAL-PHOTO POSTCARD). Almost 30 years before the Santa Clara County Fairground found a home at its current site on the corner of Tully Road and Monterey Highway, the San Jose Driving Park was born. In 1910, a one-mile dirt track was laid out on the 79-acre Mira Monte Ranch. The Mira Monte Stock Farm was known for raising championship racehorses. The county purchased the land in 1940 and held the first county fair at the site in 1941.

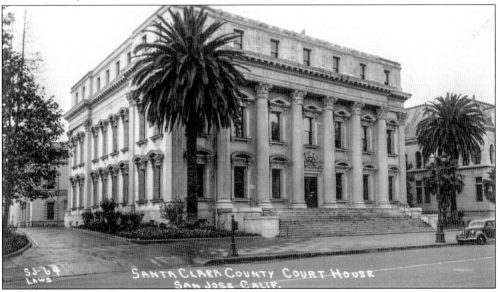

SAN JOSE, COUNTY COURTHOUSE, C. 1940 (REAL-PHOTO POSTCARD). Constructed in 1867 and opened on January 1, 1868, at a cost of $200,000, the courthouse, now known as the Old Courthouse, is still in use today. In May 1931, a devastating fire spread through the courthouse and actually melted the dome top. It reopened in 1932 without the dome but with an additional floor added to the original two floors. The Hall of Records (building on the right) was demolished in 1966. The building on the left is the old county jail, constructed in 1871 and torn down in 1959. (Published by Casper Laws.)

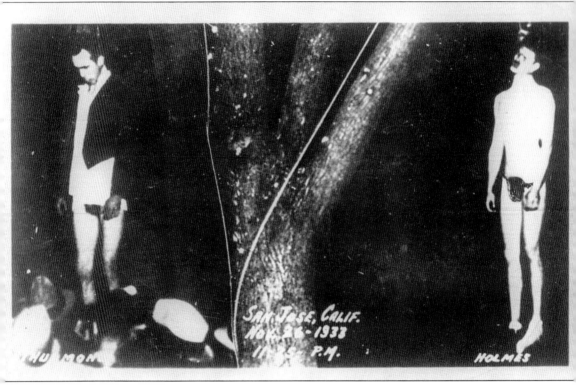

HANGING OF BOTH THURMOND AND HOLMES, C. 1933 (REAL-PHOTO POSTCARD).
Brooke Hart, the son of Harts Department Store owner Alex Hart, was 22 years old when he was kidnapped outside his father's store in downtown San Jose on November 9, 1933. The kidnappers, John M. Holmes, 29, and Thomas H. Thurmond, 28, were broke and needed money, so they made plans to kidnap Hart and hold him for a $40,000 ransom. While still alive, Brooke was thrown from the San Mateo Bridge into the San Francisco Bay. A few days later, Santa Clara County sheriff William J. Emig and his deputies were able to track Thurmond to a parking garage and arrested him. He soon confessed and gave the location of Holmes. On November 25, two duck hunters discovered Brooke's body about a half mile south of the bridge. After word of the discovery reached San Jose, an ever-growing crowd assembled outside the county jail. (Published by Defender.)

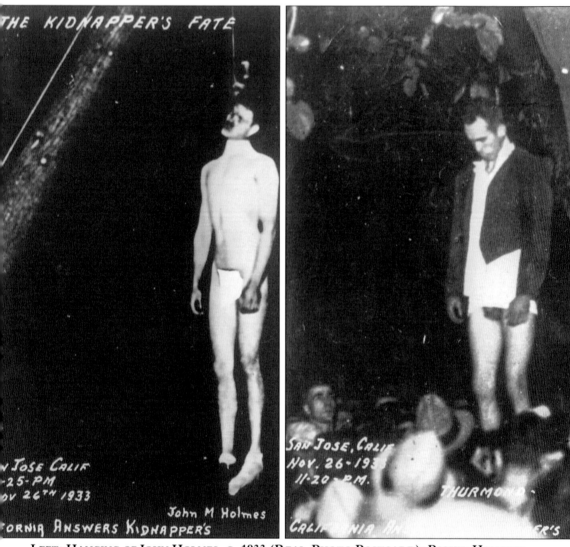

LEFT: HANGING OF JOHN HOLMES, C. 1933 (REAL-PHOTO POSTCARD); RIGHT: HANGING OF HAROLD THURMOND, C. 1933 (REAL-PHOTO POSTCARD). On November 26, 1933, at 11:25 p.m., an angry mob of citizens broke through the heavy door and rushed into the Santa Clara County Jail, forcefully pulling Thomas Thurmond and John M. Holmes out of their cells. The men were dragged across the street to St. James Park and lynched from two elm trees. The next day, California governor James Rolph proclaimed that he would make sure that no one involved would be prosecuted. In all of the following years, with estimates of 3,000 to 10,000 persons having been involved in the mob, no witnesses were ever discovered. (Both, published by Defender.)

BEAUTIFUL FOOTHILLS, POSTMARKED AUGUST 24, 1909 (HAND-COLORED POSTCARD).
A general view of the hillsides in Santa Clara County shows where early settlers set up homes and began planting crops, vineyards, and orchards. (Published by M. Rieder, Publ.)

LOS GATOS FOOTHILLS, C. 1910S (DIVIDED BACK POSTCARD). The back of the card reads, in part, "We are having the loveliest rest. I am sitting on our porch in the sun writing this. We have the grandest view from our cottage. . . . Last night we took a two mile walk to two beautiful lakes. . . . From the top of one of the hills we could see San Jose plainly." (Published by H.J. Crall Books, Stationery and Periodicals.)

10613. Santa Clara Valley in Bloom, near San Jose, Cal.

SAN JOSE, VALLEY IN BLOOM, C. 1910 (DIVIDED BACK POSTCARD). Possibly a photograph of the southern portion of the Santa Clara Valley, this view looks toward the east foothills, where farms and ranches that once stretched for miles were replaced by tracts of homes, strip malls, and office buildings. (Published by the Acmegraph Co.)

Gilroy, Cal. - Some of the Orchards.

GILROY, ORCHARDS, POSTMARKED AUGUST 7, 1915 (HAND-COLORED POSTCARD). This is a typical view of the early Gilroy farms and ranches where orchards were once planted and are now home to vineyards and wineries, producing millions of dollars' worth of local wine. (Published by Pacific Novelty Co.)

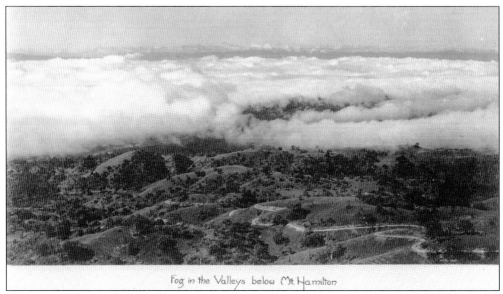

Fog in the Valleys below Mt. Hamilton

MOUNT HAMILTON, FOG IN THE VALLEY, C. 1940S (REAL-PHOTO POSTCARD). The Santa Clara Valley has the perfect ingredients to produce those nice foggy mornings. With the warm air from the Central Valley, along with the cooling effect from the coast, Santa Clara Valley has an average of 65 foggy days a year. That trends well with the 260 days of sunshine and only an average of 57 days with measurable precipitation.

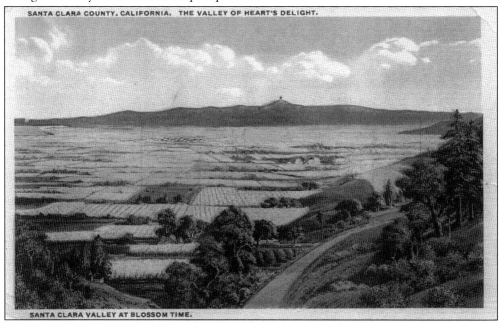

SANTA CLARA COUNTY, CALIFORNIA. THE VALLEY OF HEART'S DELIGHT.

SANTA CLARA VALLEY AT BLOSSOM TIME.

BLOSSOM TIME, POSTMARKED SEPTEMBER 24, 1915 (ADVERTISING POSTCARD). Produced to promote Santa Clara County fruit, the card's back reads, "Santa Clara County produces one-third of the world's prune crop. Santa Clara County is famed for its prunes which are unexcelled for flavor, rich in sugar, sun dried and packed under sanitary conditions. Insist upon Santa Clara County prunes. Santa Clara County also leads California in the production of apricots and cherries." (Published by Cardinell-Vincent Co.)

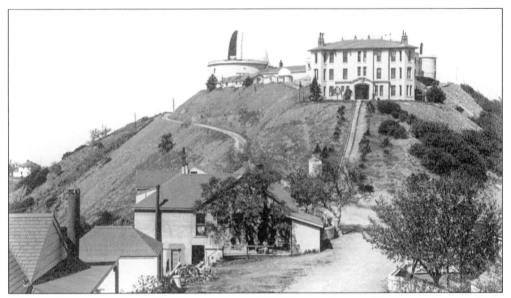

MOUNT HAMILTON, LICK OBSERVATORY, C. 1907 (REAL-PHOTO POSTCARD). James Lick, once the richest man in California, had a strong interest in astronomy and stipulated in his will that $700,000 would go to the University of California for the construction of an observatory. He had chosen a site on top of Mount Hamilton and was able to persuade Santa Clara County to build a "first-class" road to the site. Lick died in San Francisco in October 1876. In 1887, his body was moved to Mount Hamilton and buried under the future home of the refracting telescope.

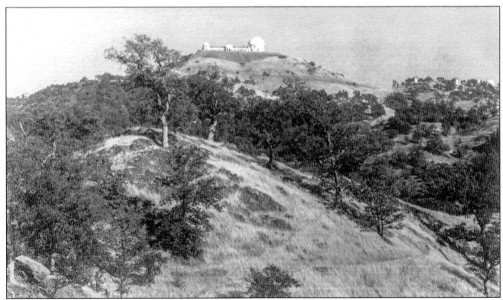

MOUNT HAMILTON, OBSERVATORY, C. 1907 (REAL-PHOTO POSTCARD). In early 1888, a 36-inch refracting telescope, the largest refracting telescope in the world at the time, was installed atop Mount Hamilton. In another first, in May 1888 the observatory was officially turned over to the regents of the University of California, becoming the first permanently occupied mountaintop observatory in the world.

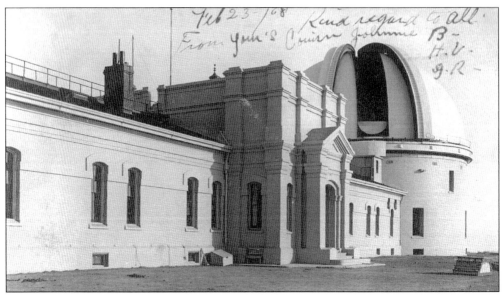

MOUNT HAMILTON, MAIN BUILDING, POSTMARKED FEBRUARY 24, 1908 (REAL-PHOTO POSTCARD). Demonstrating the engineering feat of the main building, a US Army Air Force Northrop A-17 attack plane crashed into the building during a heavy fog. The pilot, Lt. Richard Lorenz, and passenger Pvt. W.E. Scott were killed in the crash, but the building came out unscathed.

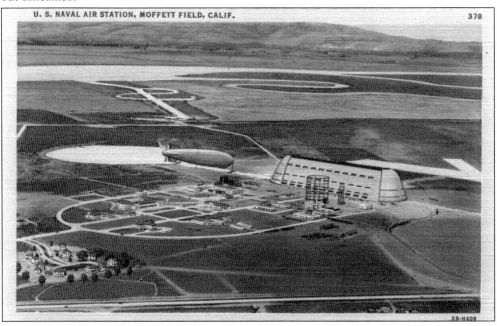

MOFFETT FIELD, BIRD'S-EYE VIEW, C. 1930S (LINEN POSTCARD). With an act of Congress signed by Pres. Herbert Hoover on February 12, 1931, the air base known as Airbase Sunnyvale CAL was born. When the base was commissioned in 1933, it was renamed Naval Air Station (NAS) Sunnyvale; and with the death of Rear Adm. William A. Moffett, who was instrumental in the creation of the base, it was renamed NAS Moffett Field on September 1, 1933. (Published by Stanley A. Piltz Co.)

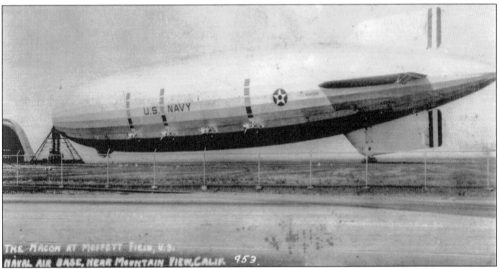

MOFFETT FIELD, THE *MACON*, C. 1930s (REAL–PHOTO POSTCARD). The 785-foot-long USS *Macon* was christened on March 11, 1933, at the Goodyear Airdock in Springfield, Ohio, and flown to California, making Moffett Field and Hangar One its new home. On February 12, 1935, the *Macon* was returning to Moffett Field when it ran into a storm near Point Sur, California. Substantial structural damage was caused when the airship was caught in a wind shear, forcing the ship to gain altitude. The commander was able to take some control and landed the *Macon* in the waters off the Monterey Bay. The *Macon* sank with the loss of two of its crew.

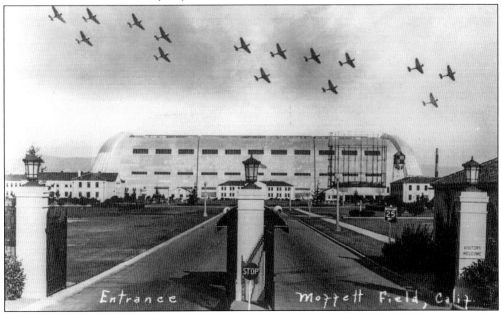

MOFFETT FIELD, ENTRANCE, C. 1940s (REAL–PHOTO POSTCARD). With the crash of the *Macon*, the Navy wanted to close down Moffett Field due to its high operational costs. Pres. Franklin Roosevelt refused the Navy's request and instead transferred the base to the Army, who assigned Moffett as a facility for the Western Flying Training Command. After the attack on Pearl Harbor, Moffett Field became an important part of the protection of the West Coast and was transferred back to the Navy on April 16, 1942.

DISCOVER THOUSANDS OF LOCAL HISTORY BOOKS FEATURING MILLIONS OF VINTAGE IMAGES

Arcadia Publishing, the leading local history publisher in the United States, is committed to making history accessible and meaningful through publishing books that celebrate and preserve the heritage of America's people and places.

Find more books like this at
www.arcadiapublishing.com

Search for your hometown history, your old stomping grounds, and even your favorite sports team.

Consistent with our mission to preserve history on a local level, this book was printed in South Carolina on American-made paper and manufactured entirely in the United States. Products carrying the accredited Forest Stewardship Council (FSC) label are printed on 100 percent FSC-certified paper.

MADE IN THE USA